You Can Crush the Flowers
A Visual Memoir of the Egyptian Revolution

by Bahia Shehab

Gingko, 2021

Dedicated to my daughters

First published in 2021 by
Gingko
4 Molasses Row
London SW11 3UX

A catalogue record for this book is available from the British Library.

ISBN 978-1-909942-53-0
eISBN 978-1-909942-58-5

This book was designed by Ragea Abd Allah.
This book is typeset in Alegreya Sans.

Printed in the Czech Republic
www.gingko.org.uk

في ذكرى

مارك لينز

Table of Contents

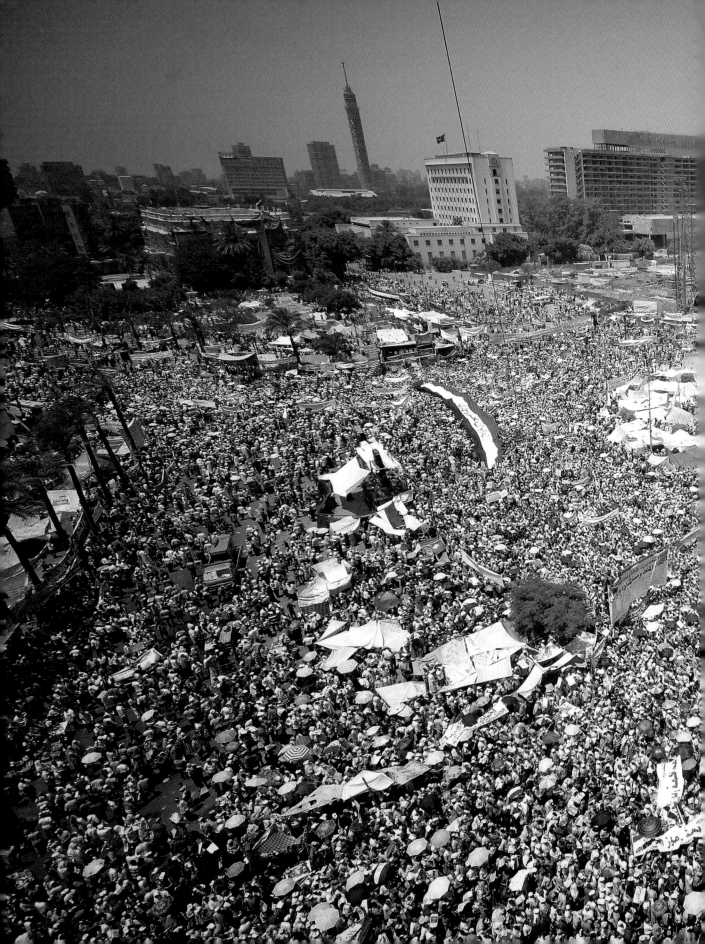

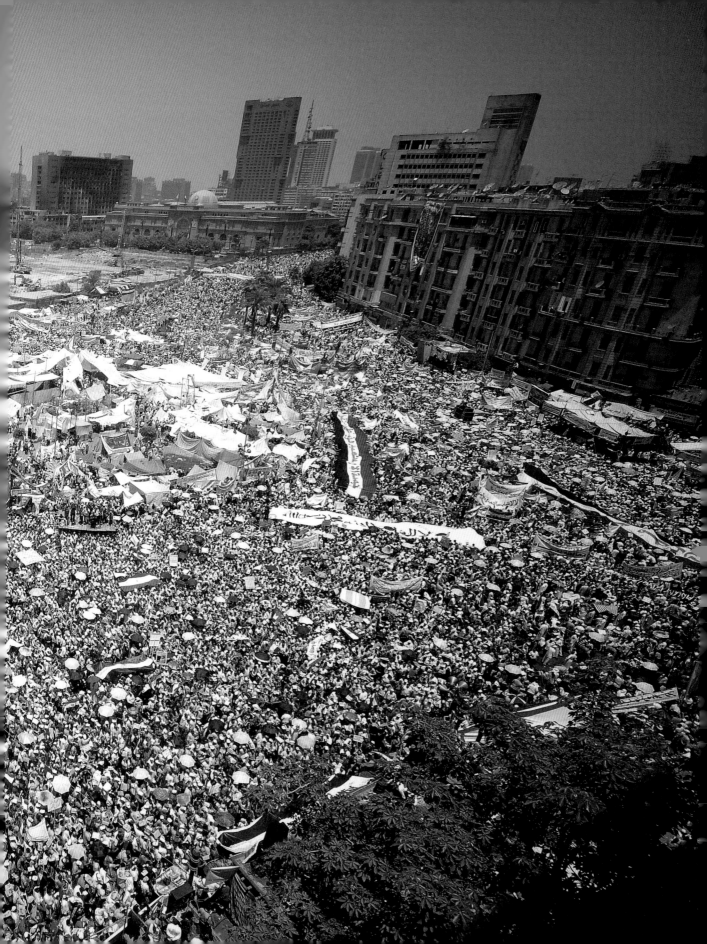

Introduction

I am not a rebel. When the revolution started on 25 January 2011, I was in Cairo watching the events unfold like so many others all over the world: on a screen. I was never in Tahrir Square during the first 18 days of the revolution. I neither smelled tear gas nor was beaten with a policeman's baton. Snipers did not take out my right eye. Armed thugs did not chase me with hatchets. My face was not the last sight seen by a dying stranger as I held him in my arms while he breathed his last. I never chanted for the ousting of Mubarak. I never served in a field hospital set up in a nearby mosque. My blood did not leave a trail on the asphalt for others to document and share on social media.

If I were to meet myself ten years ago, I would tell her: 'Brace yourself! Everything is going to change. Not for the better and not for the worse. But inside you walls are going to come crashing down and you will walk out a free woman.' To me this might be the most meaningful outcome of a revolution: it shakes our being and shifts the course of our lives. Because it is only in shifting an individual perspective that real change can ever happen, no matter how long it takes.

When I moved to Cairo in 2004, I wanted to ask my well-to-do friends who had been living in the country all their lives, how come their necks didn't hurt from looking the other way every time they saw a pile of rubbish on the streets or a beggar knocking on their car window. How do you cope with seeing misery every time you walk in the city and how does it not affect your soul? How long does it take you to become desensitised? I suspected that each person must have developed their own logic and internal coping mechanisms, and that I would eventually develop mine.

When the revolution started, I thought that it had nothing to do with me. I was not born in this land and none of this is my business. I watched and documented as a historian and the outsider I believed I was. But the walls, they started falling, and I had to rationalise my actions and understand my reactions. I had to realise that the walls that were falling inside of me were bigger than my small self. We have been conditioned to accept what is unacceptable; to live in a society that has been groomed to give up on freedom in exchange for security; to accept poverty as a given and apathy as strength; to pray to the wrong gods and celebrate the wrong achievements. During the Lebanese civil war, I was taught never to discuss politics because doing so can get you killed. Walk close to the wall and mind your own business. As a human I learned that there were layers of oppression, and as a woman these layers became thicker.

When the walls fell, the world got smaller and not bigger as I had expected. I thought, as a prisoner of the ideas that were imposed on me by society, that this liberation would be the ultimate freedom. I never expected the burden to be so heavy. You begin to see, and you realise that the chain of oppression runs long through history and it is a chain that continues up until today.

When the revolution started, I was alone. I had family and friends of course, but I was alone, or at least I felt that way. Those in my circles disregarded my questions at the time. Why are there children begging on the street? Why can't I walk on a clean and even sidewalk? Why do I and other women have to think about what to wear ten times before we decide to step out of our doors for fear of harassment? Why can't we drink clean water from our taps even though we live in a country with one of the biggest rivers in the world? Why are some of our most beautiful historic monuments in such a horrible condition and being destroyed? How can I escape the feeling of guilt when my fridge is full and others are hungry? Is it okay to have access to resources and to be safe yourself when others do not and are not? Why am I still sometimes regarded as an outsider even though I have an Egyptian passport, have given birth to two Egyptian daughters and even speak with an Egyptian accent? And if I do not belong here nor back in Lebanon then where do I belong? And then there is the question my eldest daughter asked me when she turned seven: why can't I (meaning herself) become president of Egypt?

After the revolution, the walls fell and the world got smaller. I will tell you the story as I saw it, but bear in mind that we were millions and this is only one point of view. Being in Tahrir Square with a huge crowd is difficult to describe. Can you imagine being stripped of respect and dignity all your life, only for people to come together, in enormous numbers, numbers your city hasn't seen come together in decades, to tell you that you deserve respect and dignity? In that coming together you regain everything that has been taken from you. Can you imagine standing in a square with so many people who are all asking for the same thing? I felt that my existence on this planet was finally justified. Even if now it all seems like an illusion, for a few months that same illusion felt real and emitted enough light to inspire the whole world.

Cairo, June to September 2020

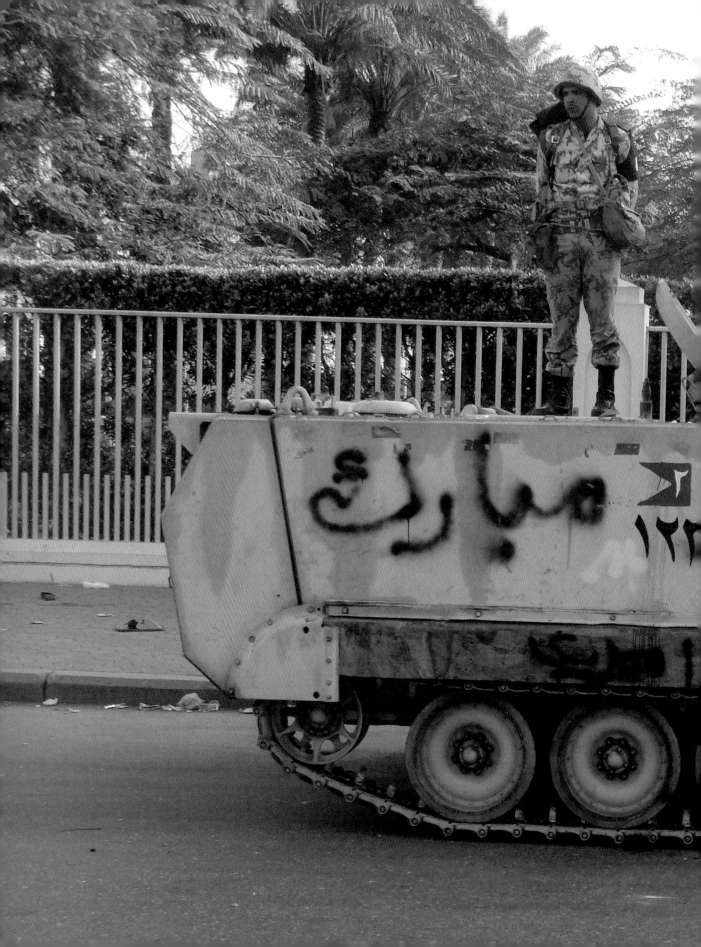

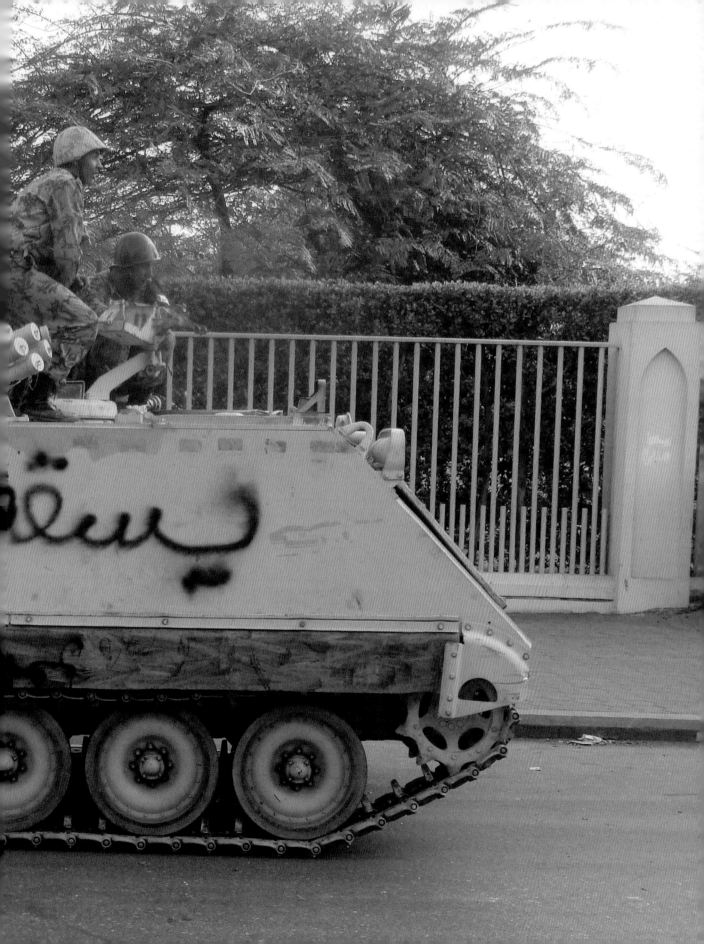

Rooms in an Imagined Museum

25 January to 11 February 2011

It took eighteen days for our president of thirty years to fall.

After he had gone, I began to imagine those days as a museum, arranged over eighteen rooms. In April 2011, I wrote up a detailed proposal and sent it to the relevant ministry. I actually got as far as attending a series of meetings with the minister, who seemed surprisingly enthusiastic.

The Egyptian revolution was ignited in the cybersphere and kept alive through a plethora of different forms of communication. The internet was a hero of the revolution. I wanted to pre-serve as much as possible of the images and sounds — video recordings, chants, posters, banners, slogans and street art — documenting the revolution and serving as its driving force. I wanted to create a space in which people from around the world could see what it was like to be in Tahrir Square, and Egyptians could relive the tumultuous experience of those eighteen days, unfolding across eighteen rooms.

In the end, the museum never came into existence. But it still exists in my imagination.

<div align="center">**</div>

The visitor enters a room painted in black. Everything is black: the walls, the floor and the ceil-ing. The visitor's first impression is one of darkness and uncertainty. Throughout the exhibition black colour represents the old regime.

In this big black room, a single small flat screen is flickering on one of the walls. The screen is showing different clips of video messages, songs, newspaper headlines, flyers and so on, that were circulating on the internet before the 25 January demonstrations, calling for action. This one small screen is a window of light.

25 January is a national holiday in Egypt; it is celebrated as Police Day. I see calls for protest demonstrations in Tahrir. What for, I am not sure.

Ten days ago, when President Zine El Abidine Ben Ali of Tunisia was ousted, I posted on Facebook the sentence 'Bye bye Ben Ali'. For a month we have watched the demon-strations in Tunis online after the young street vendor Bouazizi set himself on fire in public and died a few weeks later. But this will never happen in Cairo. Gamal Mubarak will probably be the president next. His mother has been preparing the ground for him

Previous page:
2. Military tank with
graffiti 'Down with
Mubarak',
28 January 2011

for a couple of years now. The online calls for action are very emotional, but it all seems impossible. Egypt is not Tunisia.

In the second black room, the screen has multiplied into three screens playing any footage we can find, from people's personal cameras, news agencies, the internet, and newspapers to various digital media.

The next morning, we wake up to no internet access on our mobile phones, but the landlines are still working. The demonstrators have been chased away from downtown, closer to my area of residence. I hope that they don't lose their momentum. My friends and family are checking on me either by phone calls or email. I guess everything looks quite amplified on the media. But we are fine. I keep refreshing my news feed and then checking what is being said on TV, and I feel like I am living in two different countries. This is becoming surreal very quickly.

In the following rooms the screens keep multiplying, eventually covering the black of the wall, with each room screening the events of the corresponding day. This represents the build-up of events and the development of the revolution.

The following morning there are no signals on any of our mobile phones. Everything is down. I laughed out loud in the living room. The regime is so out of tune with the world. They did not get the memo that the internet is now a basic need.

I am crying and watching one of the biggest marches I have ever seen in my life on TV. They are killing protestors on the street with live ammunition. Protestors call this day 'Friday of the Martyrs'. Hundreds of people have been shot or wounded. Police forces have been withdrawn from the street, unable to face the increasing numbers of protestors. The military is deployed across the country, and I don't feel good about this as I don't have good memories of seeing tanks in the city, but for some reason the crowds are cheering so it must be a good thing.

These screens represent the number of people that are joining the revolution. And it is their photos and their video footage that we will be playing in each room.
Phones are back on line, but there is no internet access. Protesters are still flooding

the streets and everyone is tense. The whole country is in lockdown. We keep flipping through channels and watching international broadcast footage from Tahrir while state TV is in denial. We see videos of people getting killed on the streets in Cairo, Alexandria and other parts of the country where protests are breaking out.

Ahmed Bassiouny has been killed. He was an instructor in Fine Arts at Helwan University and had two children aged one and six. He was a friend and student of some of my friends who are all sharing the news of his brutal killing.

We keep calling our friends who are in the square and they confirm that the numbers are increasing. Google and Twitter are providing a service for protestors called 'Speak to Tweet', for reporting without the need for internet connection, using #Egypt. I have no idea how it works but it's working.

The screens might play the same film simultaneously if it is an important one, or they might each play a different film. By mimicking the audio of the day in surround sound we can recreate the mood as well.

The march of the people stretches from Tahrir to Mubarak's palace. I don't know how many people are actually participating, but it looks like a million, and I am in tears watching it all unfold on TV. Seeing such a great number of people walking together as one mass is a solemn sight.

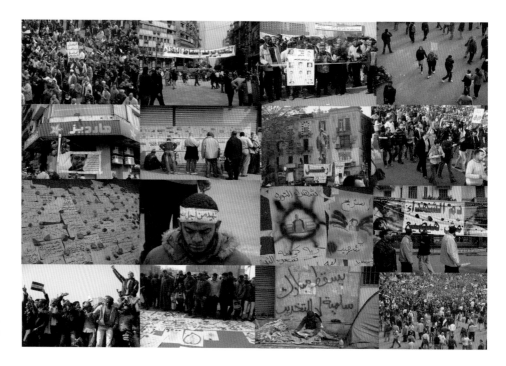

3. Photo collage of images of demonstrations in Tahrir Square on 25, 28 January and 2, 7 February 2011

For example, a wall full of screens can display a speech by Mubarak, while the screens on the other wall display the people's reactions to the speech in Tahrir Square. So, as you stand, you will see an event and its outcome.

Mubarak delivers a speech in response to the march: 'This dear nation ... is where I lived, [blah blah blah] ... I fought for it and defended its soil ... [blah blah], sovereignty and interests. On its [blah] soil I will die ... History will judge me like it did others.' The people's outraged answer is echoing across Tahrir Square: '*IRHAL!*' (LEAVE!)

Tahrir Square keeps filling up. Enormous banners are printed with the message: 'The People Want to Overthrow the Regime.' There is also a large poster of martyred bodies covered with blood, and a banner bearing the picture of Ahmed Bassiouny, the martyred artist. State television announces that protesters should evacuate the square because violent groups are heading to Tahrir.

Today's newspaper covers are hanging on the door of a closed shop for passers-by to read. Demonstration signs have been collected in a display for people to see and there is a sense of purpose and unity.

And this play on footage and events should occur in every room creatively. In the incident of the camels, as another example, the footage can move around the screens, mimicking the movement of the horses and the camels, etc...

Images of men on horses and camels carrying swords and hatchets start filling my timeline. They have been unleashed on the crowd and are attacking protesters. They look like a hired mob from a tacky period movie, and someone has forgotten to brief the costume designer.

The first step after the compilations of all the footage is an editing process to decide what should be kept in the exhibition and what should be moved to the museum's archive for future use by researchers. Each day of the revolution will have a minimum of six hours of edited footage, cut to produce the maximum impact on the visitor.

Every Friday marches start from mosques after the Friday prayer, from different parts of Cairo, and head towards Tahrir. The chants, the songs, and the creativity of it all are inspiring. I am either crying while viewing an image or watching a video, or laughing out loud at a meme. Will we be as lucky as Tunis?

People are being killed and injured in Tahrir and all over the country. In another lame announcement Mubarak states that he is tired of ruling and a fresh wave of memes washes over social media.

Media people are resigning from their posts on national TV and celebrities are joining protestors on the street. The journalist Shahira Amin walked out of Nile TV today. Celeb-

rities are starting to take sides. The divide is becoming sharp and it is not an age divide. Those who are with the revolution are in the square posting their photos of solidarity online or giving media interviews. And those against it are being hosted by state television or declaring their sentiment, or that of the people hiring them, on social media.

Some government supporters' statements are being transformed into revolutionary memes and they are genuinely hilarious. Supporters of the regime adopt the very well-known narrative of 'this is a foreign conspiracy and we should all be aware'. All my life I have lived with this story of a foreign conspiracy, no matter where I lived. I have had enough of it.

This technique ensures a second, and third, and even fourth visit since you can never view the events of a particular day in one visit only, and you would need at least 6 to 12 hours in each room to see all footage. Thus every time you visit the exhibition a different experience will be playing in a different room. It can also be a good educational tool for school children to learn about Tahrir and the revolution.

Meanwhile, in the square, every day we discover a new figure who suddenly becomes public. Wael Ghonim has been released. He's an Egyptian Google employee based in Dubai and the founder of the 'We are all Khaled Said' Facebook page that called for the demonstration on 25 January.[1] He is being celebrated on social media as a hero and has nearly become a cult figure. His Facebook page has millions of followers. He was detained for 11 days and there are lots of photos and videos of him being shared online. He is crying and laughing and dancing like the rest of us, and at the same time being heavily criticised and made fun of by regime supporters. He seems honest and in shock at how fast events have unfolded.

We turn the TV on again and wait for Mubarak's speech. Is he stepping down? No, he is not, he is delegating powers and amending some laws and fighting crime and being the Mubarak that he is. He's not going anywhere, it seems. The reply comes again from the square as people start raising their shoes up to the sky shouting loud and clear: *'IRHAL!'* (LEAVE!)

A feeling of elation and relief comes in the final room that is fully covered by screens on all four sides, with the walls all painted white. It is a simulation of standing in the middle of Tahrir Square with all its sounds and sights; a completely opposite feeling to what was felt in the first black room. We have moved from darkness into light, from silence into sound, from fear into ecstasy.

11 February 2011. Protestors are becoming more and more creative with naming the Friday marches. They are marching to the palace and there is news that Mubarak and his family have fled to Sharm el Sheikh by helicopter. I can feel the tension in the air even in my quiet neighbourhood. It feels like time has frozen. I am at home, but I feel the anxious anticipation of 84 million people as well as others around the world waiting

for an announcement. I am ready to be disappointed because I know that the fight will take longer and people will stay in the square regardless, but I hope that we can stop the killing. It can't go on like this.

It is 6pm and there is an announcement by Vice President Omar Suleiman. Mubarak has stepped down and the military council is now in charge of the country. I sob, open my house's door and start running in the street. I have been alone at home and now I want to tell any human being I see that Mubarak has stepped down.

It is 8pm. I have picked up my two daughters and their grandmother and walked to Tahrir Square.

'Raise your head up high! You're Egyptian,' people keep chanting. I take photos of my daughters and their grandmother. One day they will show them with pride to their granddaughters. They will tell them that they were there, that they witnessed history. Flags, street vendors, loud music, big crowds, nothing short of a big festival. We are feasting on the corpse of an entire regime.

Two teenagers are standing on the Qasr el-Nil bridge that leads to Tahrir Square with a sign that reads 'Free Hugs' in English. I thought those only existed in the virtual world! I go forward, a daughter in each hand, and I offer them a group hug. Egyptians from every background and social class are in the square. This is the real face of Egypt. I take the girls back home and put them to bed, and return to Tahrir myself, this time with my husband to meet our friends.

It is 1am and the morning newspapers have started circulating. *Al-Ahram*'s headline reads 'The People Have Overthrown the Regime'. The words are large and red, and placed above the *Al-Ahram* logo; I have never seen anything like this before. The newspaper didn't use a traditional, typed font either; instead they called on a calligrapher to hand-scribe the headline. For such a historic event, no typed font was worthy enough. As an Arab designer, I have to hide my face in shame, as this serves to remind me that we have until now failed to produce a font worthy of depicting historic significance. Even at the climax of a historic event, I can't think of anything but our shortcomings.

Please let me celebrate tonight. Everybody is dancing on the street. Loud music resonates everywhere in downtown streets that were witnessing death and violence only a few hours ago and are now filled with insurmountable joy. Please let me celebrate tonight, even if this young ignorant man insists on rubbing his hand on my behind in the crowd. Please let me celebrate tonight. My husband can only walk behind me, now that he knows, because we don't want to start a fight, not tonight. The air smells of firecrackers, sorrow, traces of tear gas, anticipation, long sleepless nights and freedom.

ط النظام

سلامة المغربي

البنك الأهلي المصري

NATIONAL BANK OF EGYPT

رئيس التحرير

أسامة سرايا

أغسطس ١٨٧٦: سليم وبشارة تقلا

الطبعة الأولى

٢٤ صفحة ١٠٠ قرش

Al-Ahram

Saturday **12 Feb . 2011**

٤٥٣

الشعب أبة

رئيس مجلس الإدارة

د. عبدالمنعم سعيد

البنك الأهلي المصري
NATIONAL BANK OF EGYPT

الخط الساخن لـ «الأهرام» ١٦٥٤٥

الأ

تأسس ٢٧ ديسمبر ١٨٧٥ . أصدر العدد

www.ahram.org.eg

السبت ٩ من ربيع الأول ١٤٣٢ هـ ـ ١٢ فبراير (شباط) ٢٠١١م ـ ٥ ـ أمشير ١٧٢٧ ق

السنة

2 The Calligrapher's Headline

12 February 2011

Is *Al-Ahram*, the oldest newspaper in the Arab world and in circulation since 1875, the only newspaper capable of understanding the nuances of Arab design heritage?

In the Islamic tradition, the Quran is scripted and not typed. By using a calligrapher and not a font, *Al-Ahram* has linked itself to the handwritten signs of the protestors in Tahrir Square. Their headline of 12 February, delivered in the early hours of the morning to a jubilant Tahrir Square, is a hand-written mark that cannot be merely deleted by the click of a cursor. They have engraved a fact in history.

It is a call for another kind of revolution as well — a wake-up call for Arab designers to take their place in the international design arena, something they will never be able to do without the most basic tool of design, typography. As Arab designers all around the world today, we have grown up feeling orphaned. We look at a thousand years of rich artistic endeavour, yet we still study and apply the design logic and tools of the West, which, both literally and metaphorically, move in another direction.

Unlike Roman scripts, Arabic reads from right to left. Still more significantly, its letters are connected. To design an Arabic font, you have to design the 28 letters of the alphabet with at least 145 variations depending on how the different letters connect in a word. Add to that the thousands of word variations, that only a content aware calligrapher is capable of producing, and the challenge looks almost insurmountable.

The 'designed word' is at the heart of Arabic calligraphy. The word for calligraphy in Arabic, *khatt*, literally means line. It is the thousands of different ways of combining this line to form a word which gives Arabic calligraphy its richness and beauty.

Previous page:
4. 'The People Have Overthrown the Regime', *Al-Ahram* newspaper headline, calligraphy by Mohamed El-Maghraby, 12 February 2011

With the advent of modern digital design, Western-educated type designers have marginalised and ignored Arabic calligraphers. We are left with the pitiful fact that a language that is used by hundreds of millions of people around the world has only a few hundred fonts at its disposal, of which only a handful are usable and properly designed.

The revolutions all over our Arab nations have made us see each other's faces and realise that we speak the same language and chant the same chants. Our destiny is one. We will not be looked upon as cattle and followers anymore. We will not merely speak the same language, we will adapt it, we will share it and we will make it look good.

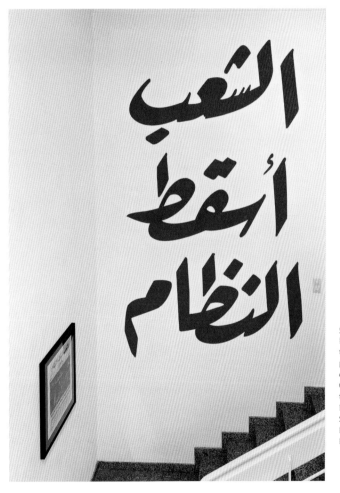

الشعب
أسقط
النظام

5.'The People Have Overthrown the Regime', wall painting, for the exhibition Beyond Gestaltung at the Bielefelder Kunstverein, 10 September – 06 November 2011, Bielefeld, Germany

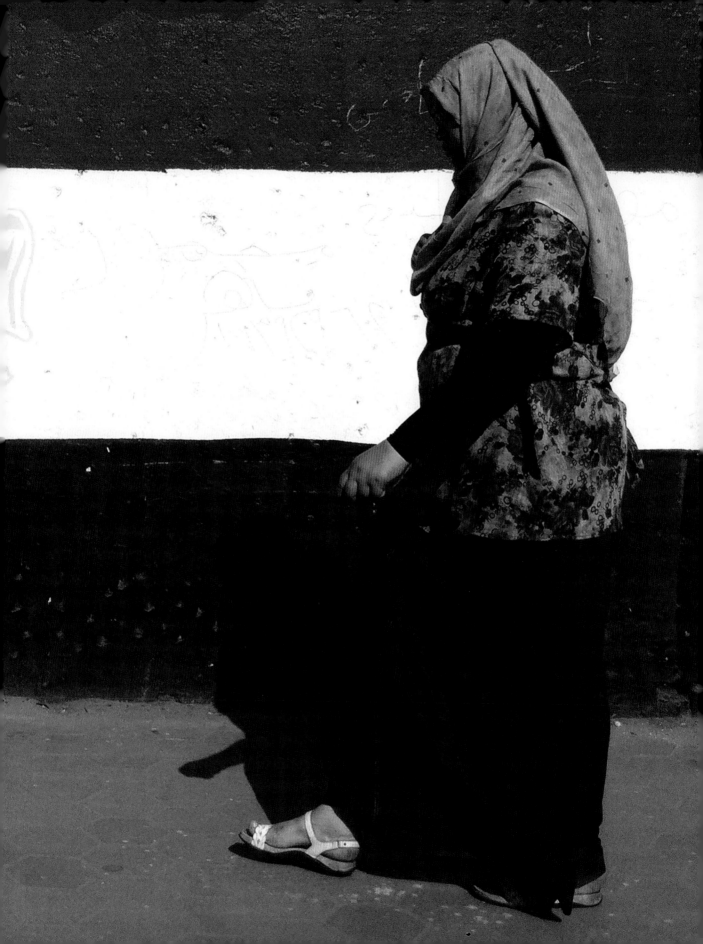

3

A State of Democratic Infancy

February to October 2011

And then?

Everything changes overnight — and yet life continues.

A few days after the fall of Mubarak I am back in class teaching (at the American University in Cairo) and I wonder if any of my students were in the square, if they are even aware of what is happening. I ask them how they feel without communicating my political views. As usual some are following the situation and others not. But the fact that at least some students are aware is already a good sign.

Social media seems to be caught in a mass post-traumatic hysterical reaction to the enormity of events. The whole Egyptian cyber community has decided to fixate on the man whose face was seen poking up behind the shoulder of Vice President Omar Suleiman as he was announcing Mubarak's resignation. Memes of the 'man behind Omar Suleiman' flood my timeline, photoshopping this nameless figure behind other political leaders in other significant political moments or inserting him into film scenes or putting him onto objects and memorabilia. I start collecting the memes, trying to understand what is happening to us, and how we are expressing it. To me, all these memes are a kind of mass genius. After a week or two there is a group on Facebook calling for an apology to the 'man behind Omar Suleiman' — apparently his family haven't been able to leave the house for days. But the jokes continue.

None of it feels real, somehow.

When Omar Suleiman announced Mubarak's resignation, he assigned power to the military council and dissolved the parliament, thereby suspending the constitution. These were two key demands of the revolution. Are we free? Is this democracy?

On 9 March the Tahrir sit-in is violently dispersed by army personnel and men in plainclothes.

Soon after, a horrific photo of the back of a young activist called Ramy Essam appears on social media. He has been leading chants of 'Down with military rule!' in Tahrir since 26 January. He was part of the Tahrir sit-in on 9 March. It seems he (along with others) was

taken to the basement of the Egyptian Museum, beaten with metal rods and electrocuted. On 19 March, all over Egypt people queue in long lines to vote in a referendum on the constitutional amendments proposed by the military council. For millions of Egyptians this is their first time in a polling station. Voters are asked to dip their finger in a red ink to prevent re-voting, just like how you get a stamp when you enter a nightclub. I go with my camera to photograph Egypt's first free vote since the fall of Mubarak.

For days people have been debating who is going to vote 'yes' and who is going to vote 'no'. Islamists have already distributed thousands of flyers and rice bags convincing people to vote 'yes' in exchange for passage to heaven after death.

I want to take photos of the ink-stained fingers of voters because people are so happy sharing photos of their red fingers after they have voted. A guy in civilian clothes outside the polling station who looks like he could be part of the Mukhabarat (the Intelligence Service) takes me to one side and asks me why I am taking photos. I smile politely at him and tell him I am practising my right to photograph whatever I please. He insists on watching me from a distance; I insist on going ahead with my work. In the end, the majority vote 'yes' to the amended constitution. Rice bags and heaven were convincing enough. I did not vote.

In April, there are more mass demonstrations in Tahrir, calling for the full dismantling of the old regime. Some army officers join the protests in uniform. The regime violently disperses the crowds and arrests the officers.

Around the same time, I break my knee while running in a race at my four-year-old daughter's school sports day. My mother flies in from Beirut to help look after me and the girls. I continue with my teaching online.

As I am stuck in bed, I expand my documentation of the revolution beyond 'the man behind Omar Suleiman', collecting images, photos, cartoons, memes of a society in flux.

I study the work of the many street artists being shared online. I start to recognise their styles and names. In Zamalek, an island in the middle of the river Nile in Cairo, an artist called Ganzeer has painted a life-sized tank facing a man on his bicycle delivering

bread carried on a board on his head. It is a simple, meaningful and beautiful image.

The Egyptian revolution caught fire so quickly that even the groups organising it were surprised. At different levels and for different reasons Egyptians joined hands and voices in saying no to the Mubarak regime. There was no visible leader for the revolution; it was almost a subconscious, spontaneous uprising. In retrospect, I wonder if we can measure how much of it was driven by our exposure to unedited news on social media?

Now Egyptians are taking to the streets to clean the areas they live in. Major companies are undertaking social responsibility campaigns for cleaning and repainting whole neighbourhoods, for the preservation of Egyptian monuments, and the eradication of illiteracy in ten years. Many Egyptians have pledged self-betterment, resolving to quit a bad habit and not to incite corruption by submitting to it. Many say they have been reborn since the revolution.

During the 18 days of the revolution, the Egyptian consensus was for the ousting of the regime. But every person in Tahrir was dreaming of their own new Egypt. The Copts want a secular state, while the Muslim Brotherhood and the Salafists want an Islamic one. The Liberals want a democratic republic, while the cronies of the old regime are counting on the short mass memory of the nation to apply a political face-lift and return to business as usual.

Copts are afraid the Muslim brotherhood will take over the country, and the Muslim Brotherhood are afraid of Liberals and their 'loose morals', while the Liberals are afraid of the percentage of Egyptians who are illiterate (statistics range from 20% to 60% — we do not have access to reliable numbers) and their effect on any ballot box.

The ongoing dialogue is not beautiful, it is not polite, and it is far from structured. It sometimes tips over into violence. But it is very active and gaining momentum. The Mubarak regime replaced democracy with an obsession for soap operas and football. Now Egyptians are participating in the political arena, forming political parties and organising their efforts with the same passion they showed in football stadiums.

Egypt is in a state of democratic infancy with the same innocent naivety, intensity, clumsiness and optimism of a child learning how to speak for the first time. Egyptians know that now they have gained the right to be part of the decision-making process of their country, and that the decisions they make now will either move their country forward in the way they want it to, or Egypt will face uglier scenarios. Egyptians feel that their democracy is not well developed; it is young, fragile and vulnerable.

That is why an enormous crowd is in Tahrir Square on Friday, 27 May 2011. They are demanding a faster trial for Mubarak, who has been enjoying a relaxing vacation in his Sharm el-Sheikh mansion on the Red Sea. They also want to remind the military, which did virginity checks on female demonstrators who were in Tahrir on 9 March demand-

ing increased women's rights, that the old ways are no longer acceptable because the people have paid the price for their voices to be heard with blood, and they demand to be heard now.

In June, I go to my younger daughter's school play. It's her first time on stage and she's wearing a red dress and dancing to a song with her classmates in a play about change inspired by the revolution.

A few days later, I go to a bookshop to buy the book my friend has published of his cartoons on the revolution. On my way there, I see tree trunks painted with the colours of the Egyptian flag in strips of red, white and black. Crescent and cross symbols are painted on the streets instead of the usual eagle of the flag. Entire walls are covered in fresh paint in the colour of the flag. An elderly man is searching through garbage heaps for food. A Vodafone campaign in large billboards on top of buildings is vowing to eradicate illiteracy by 2017. TE Data, the local phone and internet provider ad reads: 'There's a lot in our hands that we can do for our country, let's not delay.'

It feels like a new Cairo to me, like someone has washed away a thick layer of dust and the true colours are coming out. In the bookshop, I am surprised to discover that so many books about the revolution have been published so quickly. I buy twenty-five books. Some are newly published; others were banned during the Mubarak regime and have now resurfaced.

Later in the month I give a talk over Skype to the International Students Symposium on Democracy in Leiden, Netherlands, where I am being supervised for my PhD. I try to describe what I call Egypt's 'State of Democratic Infancy'. I am the only person speaking about Egypt. I want to convey something of what we have experienced.

And yet so much is unchanged. Over and again through the summer of 2011, people return to the streets to keep pressure on the regime; to insist that police and army officers guilty of attacking protesters are punished; that the regime transitions into real democracy; that Mubarak is put on trial. (His trial does finally begin in August.) Over and again, the regime responds with violence, arrests, torture, as if it cannot unlearn its old reflexes.

Online, the dreadful photo of Ramy Essam's back still circulates, along with other images of victims of the regime's attacks on activists.

In August, Amjad Rasmi, a Jordanian cartoonist, posts a cartoon about Egypt. He drew Egypt as a seated woman posing to be drawn, wearing the Egyptian flag carrying a torch in her hand with four people painting her. We can see their easels and canvases. A military man is drawing her as an empty chair, a businessman is drawing her as a closed safe with a dollar sign on it, a Salafi is drawing her as a niqabi woman, and someone who doesn't appear in the frame is drawing her as a blond woman wearing a purple tank top.

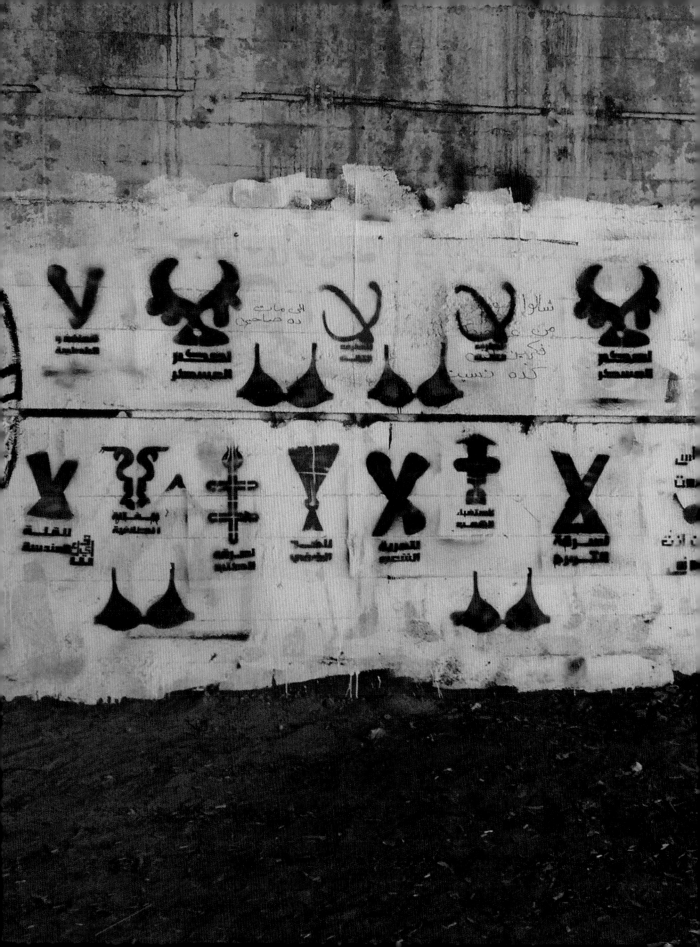

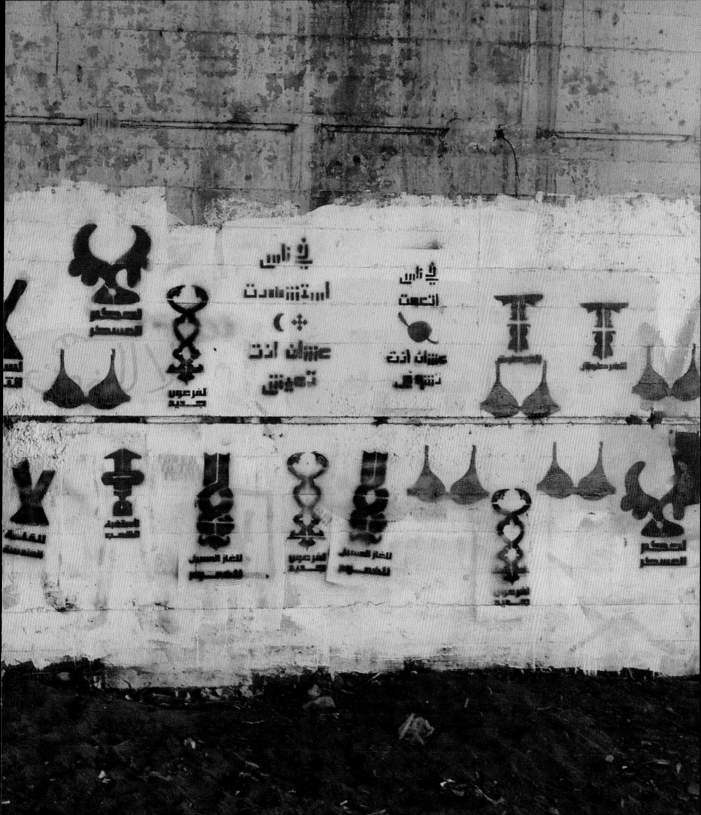

4

A Thousand Times No

November to December 2011

Nine months into the revolution, I realise that I can't remain a spectator anymore.

I can no longer hide behind the excuse of 'I am not from here; this is none of my business'.

I was born and brought up in Beirut. I only came to Egypt seven years ago. But I grew up with Egypt in my home, culturally and politically. And, more importantly, my daughters are Egyptian. This is the country my grandchildren will live in and I want this land to be worthy of its people. I reject the colonial dictation of my identity and the borders that were drawn on our lands to divide us. People just like me are being shot and killed on the street. The fact that we happened to be born on a certain patch of land should not stop us from doing the right thing. The pseudo-nationalistic mental barrier has fallen.

In March, I went to photograph the people voting in the referendum on constitutional amendments. But I did not vote myself. I have continued teaching and working on my art. I have let my broken knee heal. I have visited my family in Beirut. I have looked after my children.

I have been collecting images of the revolution — memes and jokes, cartoons and slogans, street art and posters — and what I witness has become unbearable.

Under military rule people are still being shot and gassed on the street. Last month, in October, at least twenty-four Coptic Christians died in clashes with the army in front of the Maspero building in Cairo. The Copts were protesting an attack by Muslim extremists on the Mar Girgis Church in the village of Merinab.

Previous page:
7. A Thousand Times No
(Series of 25 Stencils), Cairo,
Egypt, 16 March 2012

Opposite:
8. 'A Thousand Times
NO', Art installation at
'The Future of Tradition
— The Tradition of
Future 100 Years after the
Exhibition "Masterpieces
of Muhammadan Art"', the
Haus der Kunst, Munich,
Germany, September 2010 –
January 2011

And now in November hundreds are injured as the army fights protesters, bombarding them with tear gas. On Mohammed Mahmoud Street, one of the streets leading to Tahrir Square and right next to the Old Campus of the university where I teach, more than forty people are killed in clashes with the military.

In my newsfeed an image pops up of dead bodies piled like heaps of rubbish near Tahrir. Arundhati Roy sums up my exact feelings in her book *Power Politics*: 'The trouble is that once you see it you can't unsee it. And once you've seen it, keeping quiet, saying

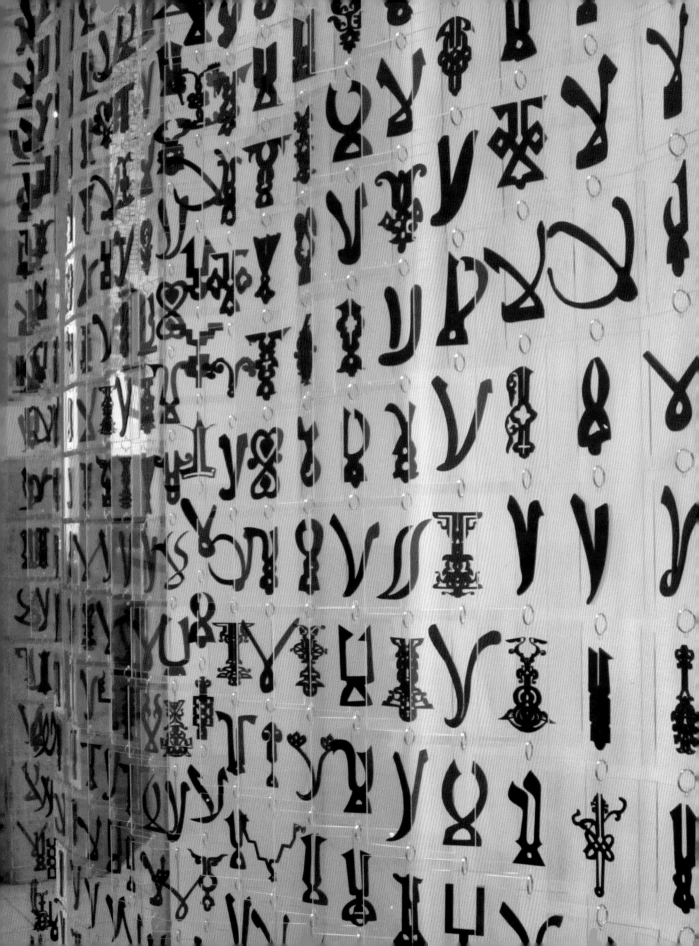

nothing, becomes as political an act as speaking out. There is no innocence. Either way, you're accountable.'

I can't sit and play historian anymore. I am an artist and all I can do is paint. So I will paint.

<center>**</center>

I began my project on '*lam-alif*' (the two letters that form the word 'no' in Arabic) before the revolution. In 2010, I was invited as an artist to create an installation for *The Future of Tradition – The Tradition of Future*, an exhibition at the Haus Der Kunst in Munich, produced by the Khatt Foundation in Amsterdam. The foundation is concerned with documenting and developing Arabic script and the exhibition was to showcase works by female Arab artists and designers. The curator had only one condition: I had to use Arabic script for my artwork.

As a human being living in today's world — as an artist, an Arab, a woman — I decided I had only one thing to say: NO. There were a thousand things I wanted to say no to. In Arabic, to stress the negation articulated in the word 'no', we say: 'No, and a thousand times no.' So I decided to look for a thousand varieties of 'nos'. I collected characters from Spain, Afghanistan, Iran, China, and all the countries where the Arabic script was used, and in all manner of constructions and objects — buildings, mosques, architecture, plates, textile, pottery, books. It was easy to find 'no' in the Arabic because the Islamic Shahadah, the declaration of faith, starts with the sentence: 'There is no God but Allah.'

With a thousand Nos, I created a plexiglass curtain, 3.5 by 7 meters.[2] I compiled my findings in a book, arranging the Nos chronologically and specified where I had found each, the medium I had used, and the patron that commissioned the work and the date.

Now my Thousand Nos are no longer a collection of random thousand 'nos'. Now I can assign a purpose, a message, to each No. The Nos will be my ammunition. I will design stencils with them and spray them on the walls and streets of Cairo. I will resurrect them from their historic graphic forms and bring them back to life.

It is Friday, 25 November 2011.

Visiting Tahrir has become, for some, the usual family outing, instead of staying at home or going to the park. But today a photograph of armed men coming out of the Ministry of the Interior near Tahrir has been shared on social media. No one wants to go down to the square with me. They say 'it is not safe', or 'f%$# the revolution!', or 'don't waste your time', or 'they will come to get you'.

Finally D. agrees. He is kind enough to bring his camera along. I can feel he is nervous.

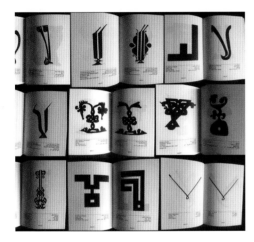

Above and middle:
9-10. 'A Thousand Times NO', 1016 page printed and digital book, Khatt 2010

Below:
11. 'A Thousand Times NO' book, Khatt 2010

Opposite:
12. 'A Thousand Times NO', Plexiglass curtain, 2.5 m x 6 m

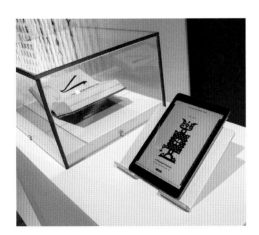

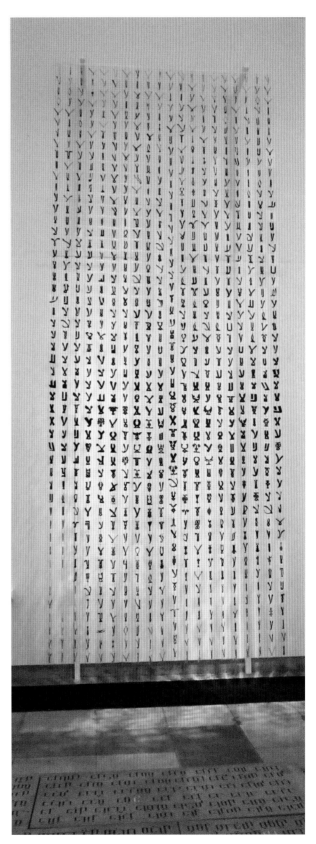

31

He keeps talking about his experience of how when he was 17 he sprayed paint on a wall back home and his father was made to pay for the damage.

All I have is one small stencil and four spray cans. My stencil reads 'No to military rule'. I took the *lam-alif* (No) from an 8th-century tombstone in the Islamic museum in Cairo. I have seen so much death circulating that only a letter from a tombstone will work. It took me one hour to cut the stencil out of a piece of grey cardboard.

It is evening. I pass the checkpoint to get into Tahrir and stand in front of the first wall near me. It surrounds the Arab League building. I nervously place my stencil against the wall and spray. The sense of liberty! It is safest to spray with a million people around because no one will notice you; you will be lost in the crowd. I am not alone in thinking this way. I can see other graffiti artists moving in groups around Tahrir spraying their messages. Maybe I am the only one who can see them because our aims are one now. I move on to other walls around Tahrir and spray some more.

People's reactions vary. Some are so supportive that they help me by holding my stencil against the wall. Others ask who will clean up after me and why am I doing this? I guess they don't realise that we are still in the midst of a revolution; they came to Tahrir for the *termis*.[3] I ignore them and spray quickly because anyone can turn violent, even with so many people around. I saw the interview with the CBS reporter: they stripped and raped her in the middle of Tahrir Square, while I was celebrating with my daughters over the bridge. A huge crowd was there and nobody saw a thing. Sometimes wilful ignorance is more dangerous than police brutality.

There goes another group of taggers. They are scurrying like rats. I guess this is what I look like from a distance too. Tahrir is packed and the crowd is waving a huge flag of Syria again. It is good to feel like you are part of a bigger whole. Only such experiences give us a sense of awareness of our existence.

A day later, I see a small note in a field hospital in Tahrir with a poem by Neruda scribbled on it in Arabic: 'You can crush the flowers, but you can't delay spring.'

<p style="text-align:center">**</p>

A wave of anger and rejection sweeps over me. After expressing my first No, I want to say no to every injustice I have witnessed.

I think back to the photo of Ramy Essam's viciously tortured back. He is just a young man who came from Mansoura, a small city in one of Egypt's provinces, to Tahrir Square a few days into the revolution carrying nothing but his guitar and a dream for a better Egypt. Back in March, when I saw that image, I was too taken with the dream of the revolution and too naive to see that the rotten system of government still stood in place.

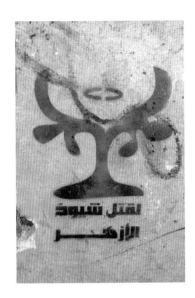

لقتل شيوخ
الأزهر

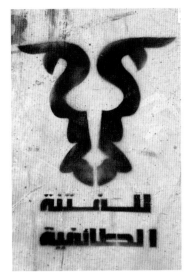

للفتنة
الطائفية

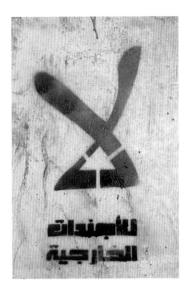

للأجندات
الخارجية

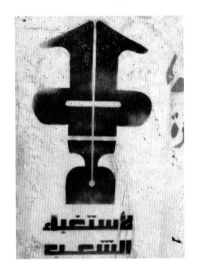

لأستغباء
الشعب

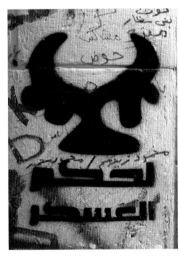

لحكم
العسكر

للقناصة
المشبوهة

لسرقة الثورة

لقانون
الطوارئ

للطرف
الثالث

33

I spray 'No to violence' for Ramy Essam.

I spray 'No to blinding heroes' for Ahmed Harara and the many protesters who have been shot in the eyes. Ahmed was shot in his right eye on 28 January 2011 and in his left eye on 19 November 2011. He appeared in a TV interview smiling and saying that if the price of freedom and dignity for a better Egypt was losing the light of his eyes, then he would willingly give them both but keep insisting that we want a better country.

I spray 'No to sniper pashas' in reference to a video circulating of a police lieutenant called Mahmoud Sobhy el-Shenawy shooting at protesters and then being saluted by one of his assistants who says to him: 'You are so strong, Pasha, you got the boy's eye.'

The Nos flow easily. Every day my newsfeed throws up some fresh horror, something else to say no to.

On Friday, 16 December, Sheikh Emad Effat (a senior cleric at the Al-Azhar mosque) is shot during a demonstration, leaving behind two orphans and a widow. I spray 'No to killing men of religion' to highlight how blind the regime is, that it does not differentiate between good and bad, that its killing machines are working brutally and randomly on the street without differentiating a thug from a peaceful protester, in this case a man of religion. For the No of this stencil I take a ligature off a tombstone at the Islamic Museum in Cairo. I thought again that since the topic is death, I might as well use a symbol from history that also belonged to death.

Many of the Nos are from historic tombstones and cenotaphs; some are from mosques. 'No to military rule', the first stencil I sprayed, and 'No to killing', both contain a 'no' from the same engraved tombstone number 1240 at the Islamic Museum in Cairo (236H / 850CE). 'No to stealing the revolution' came from another engraved tombstone in Kairouan in Tunisia (303H / 915CE). 'No to violence' was taken from the wooden cenotaph of al-Husayn at the Islamic Museum in Cairo (600H / 1200CE).

After Institut d'Égypte catches fire during clashes between protesters and the military, I spray 'No to burning books'. The 'no' comes from a cut brick inscription in the Great Mosque of Herat in Afghanistan (596H / 1200CE).[4] A copy of *Description de l'Égypte* was one of the priceless books that burned in the fire. There are other copies of the book available outside of Egypt, so this was not an utter disaster perhaps, but it's still disheartening to see this erasure of our history. What sort of regime would allow an institution as valuable as this to burn in fire![5]

On 17 December, three soldiers are recorded on video dragging a woman protester to the ground, beating her and stripping her clothes from her body, revealing her blue bra. The video rapidly circulates on social network forums and then travels the world to appear on the front pages and bulletins of news organisations around the globe.

For her I spray 'No to stripping the people'. Alongside the script, I spray a blue bra and a boot-print, the footprint of the soldier who stomped on her stomach with his boot. The

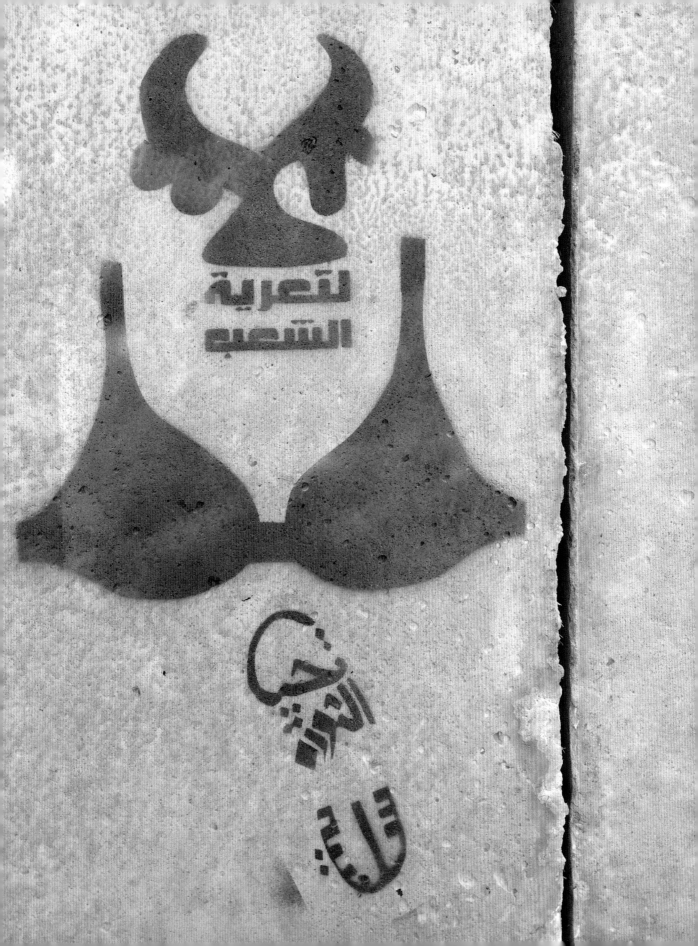

boot-print is made up of a script which reads 'Long live a peaceful revolution', because we don't believe in responding to violence with violence. This is a very difficult resolution to maintain once you witness their brutality. My respect for a character like Gandhi has increased greatly.[6]

<div align="center">**</div>

On 20 December, I watch a video online: three minutes of a camera following a trail of blood on asphalt. The blood belongs to Ramy, a young engineering student, as he walks wounded with a gunshot.

The blue-bra symbol is spreading rapidly: many artists are using it. One designer posts the eagle, the symbol of the military, wearing a blue bra on a military shoulder badge. Artists are painting the blue-bra girl and their work is being shared extensively online, often with the hashtag #SCAF (Supreme Council for the Armed Forces). The woman herself did not come forward. She is too afraid or ashamed. But by stripping her the Armed Forces stripped themselves of any respect the people had for them. Likely candidates for the presidential election that is expected to be held at some point in 2012 are all making statements criticising the armed forces.

On Christmas day my friends around the world are opening presents and I am watching protestors, not just in Egypt, but all over the Arab world, dying on the streets. I see a picture of a protester in Cairo holding a sign reading 'Accomplishments of the military council'. It then goes on to list the long series of the massacres in 2011 following the Army's attempts to suppress demonstrations, one after another, including the violent incidents outside the Maspero building and on Mohammed Mahmoud Street. At the end of the list it is written: '...To be continued.'

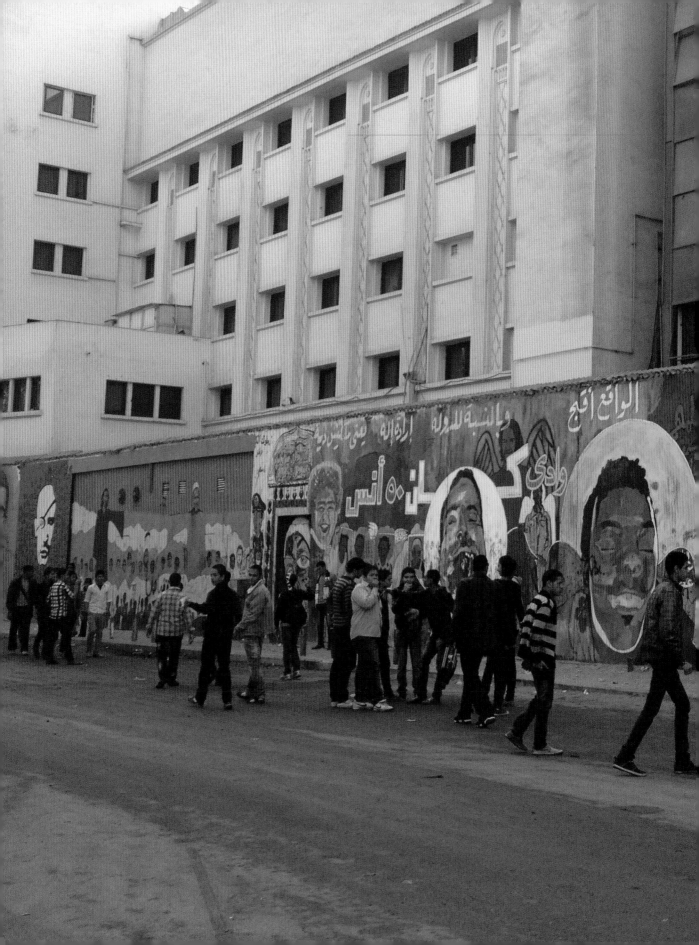

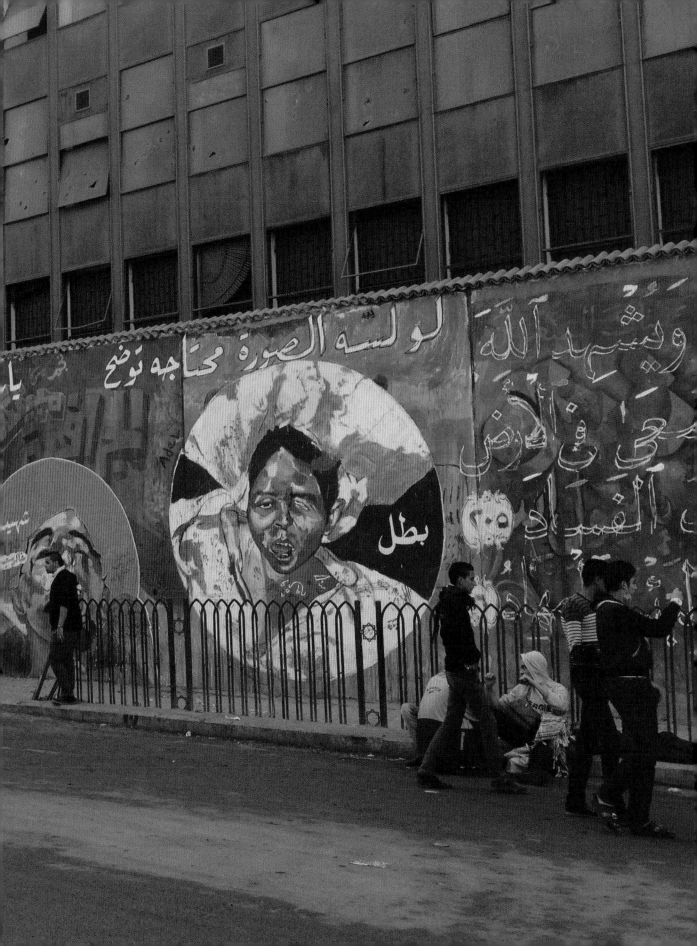

5

First Anniversary

January to March 2012

It is January 2012. The first anniversary of the revolution is nearly upon us and I am gripped by a deep sense of melancholy.

I have just returned from a week in the US and the Netherlands. Everywhere I went I found myself making comparisons. In New York, I visited the Metropolitan Museum's Islamic art section after its recent renovation. I was almost in tears seeing works of art I have studied for years quietly displayed in front of me. For my research on the Fatimids, I had booked a private viewing session of specific works. A curator met with me, led me to the storage area and allowed me to touch the artworks, with gloves on. I was over-whelmed. This simple scholarly act of studying an artwork up close would have taken months of negotiations and pulling strings at a museum in Cairo, and after all your ef-forts you might still be denied access.

I think about the social and economic structures that make the process of heritage protection possible. I do not forget that I had to apply for a visa and get on a plane for twelve hours just to see these artworks, a privilege that many scholars from my part of the world do not have. Nor did I forget that some of these artefacts were looted. In a parallel universe, these artefacts would have been preserved and protected in their country of origin and would form the basis from which artists and thinkers create new work, uninterrupted by colonisers. These objects are part of the collective memory of the people who created them; being detached from them detaches us from our history and identity.

In the Netherlands, I went to Leiden to see my PhD supervisors at the university. Leiden is a beautiful city of old, well-maintained buildings. Instead of destroying the fabric of the city to widen roads for cars, people ride bicycles. In Cairo, pavements are so uneven that a person with a disability cannot get around the city alone — as I discovered for myself when I broke my knee last year. In Leiden, I saw a disabled dog with a wheeled metal walking support, happily able to get around independently. I went to visit the children's museum in The Hague and this again made me lament the fact that our chil-dren will not grow up to have such institutions abundantly available to them. Suzanne Mubarak was working on building such a museum, which was being designed by a team of Italian interior designers. But why do we need Italian designers to design a museum for children in Cairo?

**

As the first anniversary of the revolution approaches, the old regime is fighting back. A government-employed schoolteacher has shared a printed handout with her students, asking them not to join demonstrations and not to critique the military, as this will mark them out as traitors. It's a long page that someone has posted on social media and I can't be bothered to read it all, really. And, of course, there are the usual conspiracy theories trying to portray the revolutionary factions as being funded by the US and Israel.

The revolutionaries retaliate with their customary black humour, predicting the programme of events for 25 January, the first anniversary of the beginning of the revolution:

6am – 12pm:	Demonstrators enter Tahrir
12 – 1pm:	Hosing the demonstrators segment
2 – 3pm:	Bullets and explosions segment
3 – 4pm:	The horse and camel segment
4 – 5pm:	(Ladies only) Pulling and scraping
5 – 6pm:	The clown Tawfik Okasha Toufik Omasha [pun on the name of the TV presenter Tawfik Okasha, a mouthpiece of the regime]
6 – 7pm:	The magician segment by 'the third party' [reference to externally funded 'traitors' conspiracy theories]
7 – 12pm:	Fireworks, Molotov and building a fence around the square segment
Dinner:	Pizza and ribs [reference to the actress Afaf Shoeib's comment last year that her little nephew wanted to eat pizza and ribs, but he couldn't because there was a revolution in the streets]

On 25 January, I decide to go to the square. Maybe being among the people who share the dream will make my melancholy bearable. I park my car off Qasr El-Nil Bridge and set off walking alone. I am searched by civilians and allowed into the crowd. I am engulfed by the thousands of people who are still flooding into Tahrir in groups. The fes-

tivities are genuine. As I walk, people are clapping to chants for equality, peace and a new government: 'We are the People! We are a red line! We are the People, not the military, not the police, and we are not political parties dividing up a cake! Down with military rule! They killed a Christian and a Sheikh!' Protesters are carrying posters of Sheikh Emad Effat (for whom I sprayed 'No to killing men of religion') and Mina Daniel, a Copt killed by the regime, two figures who have become symbols of the revolution and of the people's interreligious unity in the face of a regime that is killing Muslims and Copts alike.

A man holds up a sign inscribed with the word 'Silmiyya' (Peaceful). Behind him an eight-metre obelisk made of wood engraved with the names of all the martyrs is drifting slowly towards Tahrir Square over the heads of the people forming the dense crowd.

Alaa Abd El-Fattah, an activist and blogger who is a living symbol of the revolution, is giving an interview among the crowd. A few other celebrities are making appearances and being interviewed by different media outlets. Stages for different political parties have been set up and there is a strong presence for Syria with a large tent and flags everywhere. I have never seen such political diversity represented in the Arab world: the communists, socialists, Salafists and Muslim Brotherhood all have flags and leaflets and an audience. It is as if ideologies from all over the Arab world are present in Tahrir in celebration of the day. I'm alone, but I feel like I'm part of an amazing dream and that all these people who are here in the square one year after the revolution are sharing this dream with me.

<center>**</center>

On the evening of 1 February, news of riots in Port Said starts to trickle in. Al-Ahly and al-Masry, two teams in the Egyptian Premier League, were playing a football match there. Eyewitnesses reported that following the match the doors of the stadium were locked and the lights switched off. Al-Ahly supporters were attacked and 74 people were killed and more than 500 injured. The news on state television says that the al-Masry fans attacked the al-Ahly supporters following their team's victory.

The whole story sounds illogical. The Ultras — the most fanatical supporters of particular football teams — have been one of the driving forces for rallying people throughout the revolution in Tahrir and all over the country. This looks like payback. The al-Ahly supporters were trapped inside and attacked with clubs, daggers and stones. Football fans turn violent sometimes, but I have never heard of 74 deaths and 500 wounded in a fan fight.

A 'Friday of Anger' is announced with marches to Tahrir starting the day before. University Student Unions issue statements declaring a general strike to protest the revolution being sabotaged. They say they will boycott classes and hold demonstrations until their demands are met. They are asking for SCAF to hand power over to civilians and an elected government, and to end the transitional period of military rule.

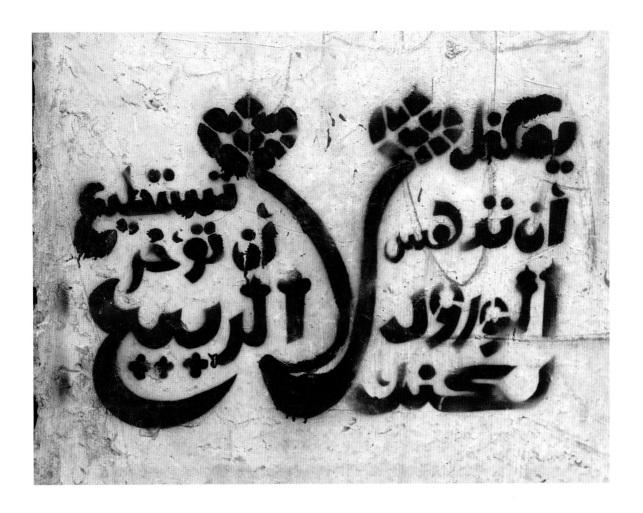

25.'You can crush the flowers but you can't delay spring', by Bahia Shehab, 2012

One of the young men killed in Port Said was a student at the university where I teach. His name was Omar Mohsen and he was due to graduate this spring. I have seen images of young men and women beaten and killed before, but this one hits especially close to home. He could have been one of my own students, sitting in my classroom one day and brutally killed the next.

I remember the poem by Neruda I saw scribbled on a piece of paper in a field hospital in Tahrir Square last November: 'You can crush the flowers, but you can't delay spring.' This one is for Omar. I draw it quickly and cut it out of a piece of cardboard. It is the first time I have been to the street to spray a stencil in broad daylight. It does not matter anymore whether I get caught or not. I am so angry. I feel sorry for the mothers who thought they were sending their children off to a peaceful football match and have welcomed them back in coffins. I do not feel that I deserve to live anymore. I spray the poem and my other No stencils around the al-Ahly club, on the walls in the small al-Andalus Street off Mahmoud Mokhtar Street and in Tahrir all around the square. I am not alone in my anger and grief. Mass demonstrations are breaking out everywhere.

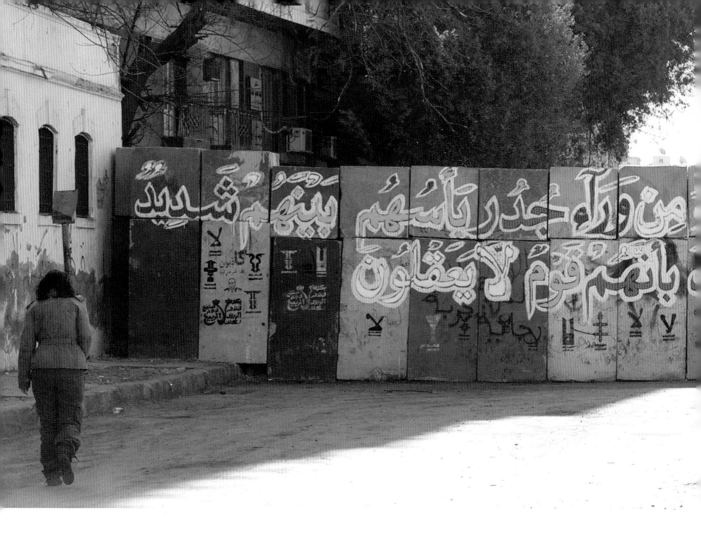

**

Since the Port Said massacre, I have become obsessed with being on the street. Once or twice a week I put my daughters to bed, fetch my stencils and spray cans and go out. In my pockets I have my keys, my phone, my ID and a little bit of money. I use the same backpack I used for my daughters' diapers and milk bottles when they were younger. The bag is ideal because it has a lot of pockets and can fit two spray cans on the side where it used to hold milk bottles. The pockets in my cargo pants fit another two spray cans and a few more fit inside the bag. I make a cardboard folder for my stencils. The screensaver on my phone is my daughters' picture. If I get caught this will be the first image on my phone anyone will see should they try to search it. Before leaving the house I always make sure I am wearing a clean pair of underwear. I don't understand why, but I think that if I get killed I want my underwear to be clean. It is a very curious thought that in the face of death what I am most concerned about is the banality of my personal hygiene. I have cut my hair very short. I don't have time to wash it with all the street work I'm doing now, my teaching, housekeeping and looking after the girls. It is also one less thing to worry about. And if someone tries to catch me on the street, they can't grab me by my hair.

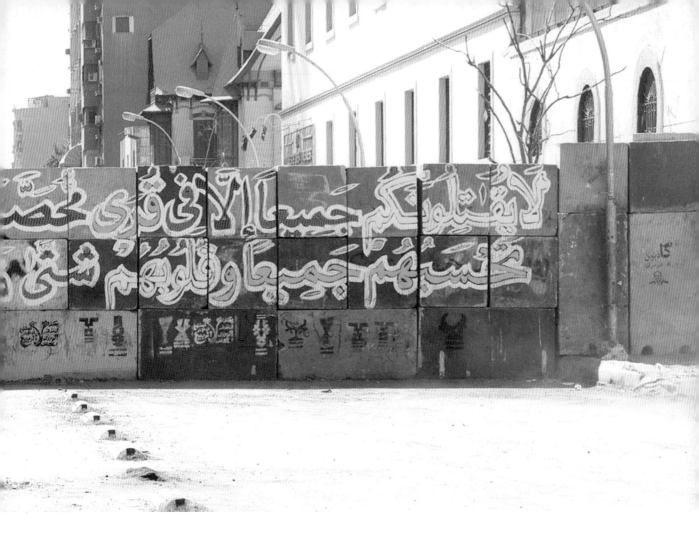

26. Calligraphic verse from the Quran on barrier wall, by Ammar Abo-Bakr, Egypt, March 2012

I ask my friend B. if she knows someone who will spray with me. She connects me with two young men who agree to join me for one night, on the condition that we spray one wall only and leave quickly. After spraying once I become afraid that organising the sprayings might get people in trouble, so I resort to another technique. I start going to cafes in downtown and connecting with people there to ask them to join me on the spot if they want to. Horreya Café is where the revolutionaries hang out and the best place to connect with volunteers. I meet random people at the Bursa Café as well, a place downtown where protesters meet after demonstrations to discuss plans or reconvene after they have been gassed by the government. The people who help me come from different walks of life: some are university professors and others are shop owners. They are mostly young with ages ranging from 17 to 40, but they all help and they all spray and some of them I never cross paths with again. In the back of my mind, I am always afraid someone will get caught because of my work, so most nights I spray alone.

I see images of the barrier walls that were set up in downtown Cairo all around the Ministry of the Interior to protect the building against protesters on 5 February. The

Port Said massacre has created a new surge of protesters, and when you are afraid you build walls. A total of seven walls have been set up around Tahrir.

Ammar Abo-Bakr, a brilliant muralist who has been on the street since the revolution started, has painted a Quranic verse in big bright fluorescent colours on one of these walls. The wall where Ammar has painted his verse blocks the street that leads to my old school where I studied for my master's degree for four years. I consider that building a home, because it houses the rare books library of the American University in Cairo. The idea that I could not have easy access to that building disturbs me. So I spray 'No to barrier walls' on that wall, and on the same night I spray it along with many other Nos on the barrier walls right in front of the Ministry of the Interior. Behind that wall are the guns and tanks used to kill protesters, to snipe their eyes out and mutilate their bodies. It is the first full wall I have sprayed. The 'no' comes from stucco at Pir-i Bakran, an Il-Khanid mausoleum in the district of Linjan in Iran (698 – 712H / 1299 – 1312CE).

In the beginning, I always went out to spray in Tahrir Square and Mohammed Mahmoud Street as the walls there were covered with the work of other artists and I felt safe. The barrier walls make for another great canvas. I spray my No series wherever I find a clear wall. When I'm spraying, I usually don't have time to document and at the same time I know that I need to record my work. I cannot post my work online, as no one in my circle knows that I am active on the street, except for my husband and two friends. But I want to capture the images for myself, because I know my work will be erased. The light at night is not great for documentation, so I head out on Friday mornings before prayer time to take photos of my work and that of other artists. I take my daughters Noor and Farah with me, because I want to show them what I have sprayed. I don't know if they will remember — Farah is four and Noor is seven — but I feel that they need to see this.

The artworks range from scribbled slogans and sprayed stencils to large scale murals. They are all beautiful. I feel like I'm walking in an outdoor museum. I am not the only one documenting; so many people are taking photos of the art on the street. I love the stencil of a man throwing a television set into a rubbish heap. Stencils of Sheikh Emad Effat and Mina Daniel are everywhere. Beautiful portraits of martyrs painted in large scale by Ammar Abo-Bakr grace the outer walls of the American University in Cairo. Some parents bring Ammar the photos of their children who have been killed in demonstrations and ask him to paint them on the walls. He has painted a big 'Glory to the Martyrs' alongside Alaa Awad's Ancient Egyptian-looking mural on the same wall. Underneath the mural someone has written the words 'The rights of the martyrs' using flowers and small bunches of mint as characters. There is no limit to the creativity that I am seeing on the street. Artists are painting near and over each other's works. There is (of course) no curation. It's so refreshing to see all the different skills and ideas appearing next to each other. I feel like the street has all the ideology of the revolution painted on its walls and I finally feel at home. The street belongs to us all.

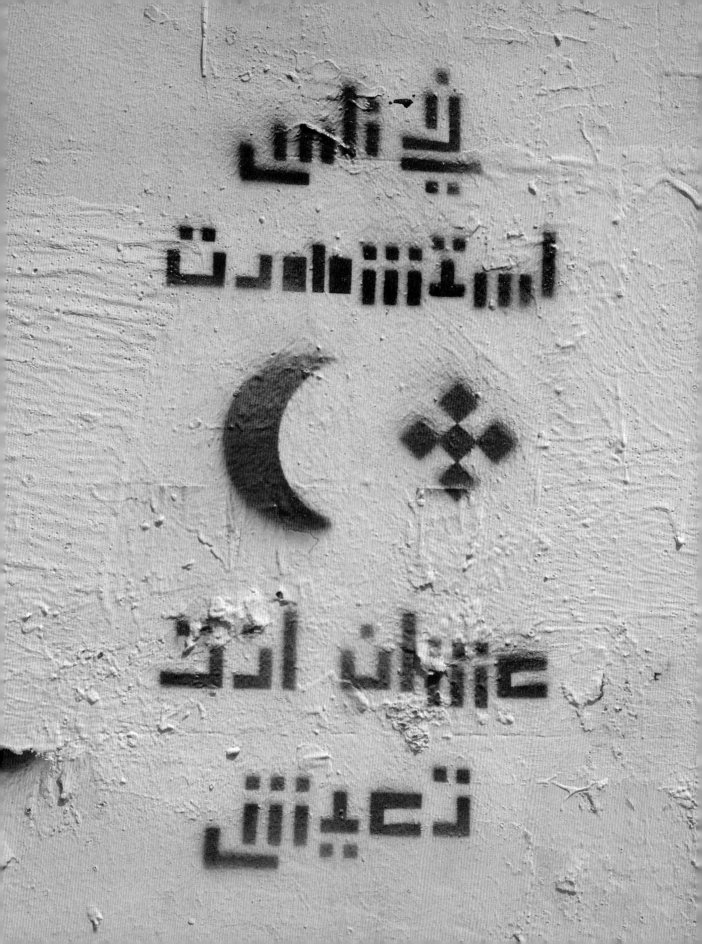

March 2012. The 'We are all Khaled Said' Facebook page has set up a poll asking people if they know how the Egyptian government spends its budget. Out of the 4600 people who answered only 663 get the answers right. So the page shares a breakdown of the government's budget. I myself had no idea how the government spends its budget because, I guess, I never felt the need or even thought that this concerns me. We have been conditioned to become unconcerned citizens so that those who are in power can do as they please.

Online, the picture of a 41-year-old woman, Nermine Khalil, wearing a matching outfit with her ten-year-old daughter is going viral. Nermine was assassinated in broad daylight in Sphinx Square in Cairo with a bullet shot to her head. She was working on the virginity tests case for the United Nations. Meanwhile, Islam Naguib, a young graffiti artist in Minya, has been charged with 'advertising without a license' and is currently detained.

Mass morale is very low, and there is a lot of anti-revolution sentiment in the air, even among people who were strong supporters of the revolution. I design a campaign to remind people of the aims of the revolution and the sacrifices others have made for us to get us where we are now. It is called 'There are people' and composed of five stencils that read:

> *There are people who have had their heads pushed onto the ground, so that you can raise your head up high.*
> *There are people who have been stripped naked, so that you can live decently.*
> *There are people who have lost their eyes, so that you can see.*
> *There are people who have been imprisoned, so that you can live freely.*
> *There are people who have died, so that you can live.*

And I know the perfect spot to spray these stencils; I'm going to paint it on one of my favourite walls.

Throughout the Egyptian revolution, street art is constantly responding to other images. Many pieces of graffiti, like my 'Children of Asyut', make reference to their surroundings. Artists also comment on and respond to each other's works, adopting motifs or modifying an earlier artist's work. Sometimes these conversations are arguments. In street art you are never safe from being painted over. As images are quoted, modified, negated, repurposed and erased walls become palimpsests, a form of visual dialogue.

The longest and most exciting of the public visual conversations between street artists in Cairo took place on the 'Tank vs Bike' wall. In May 2011, Egyptian artist Ganzeer paint-

Opposite:
Above left
28. 'There are people who have been stripped naked, so that you can live decently.' By Bahia Shehab, 2012

Above right
29. 'There are people who have been imprisoned, so that you can live freely.' By Bahia Shehab, 2012

Bottom left
30. 'There are people who have lost their eyes, so that you can see.' By Bahia Shehab, 2012

Bottom right
31. 'There are people who have had their heads pushed onto the ground, so that you can raise your head up high.' By Bahia Shehab, 2012

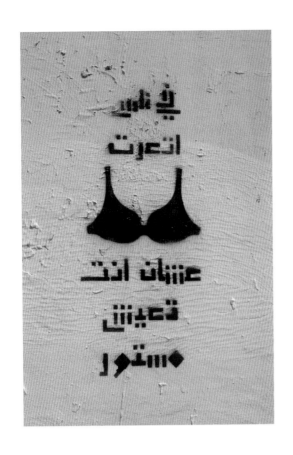

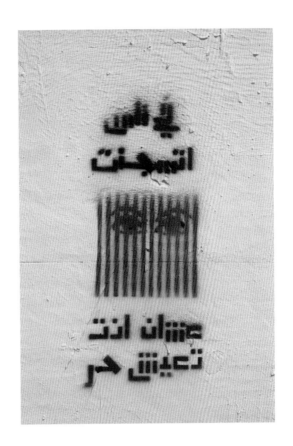

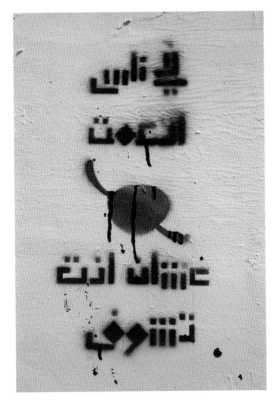

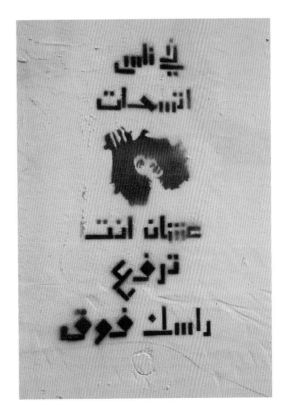

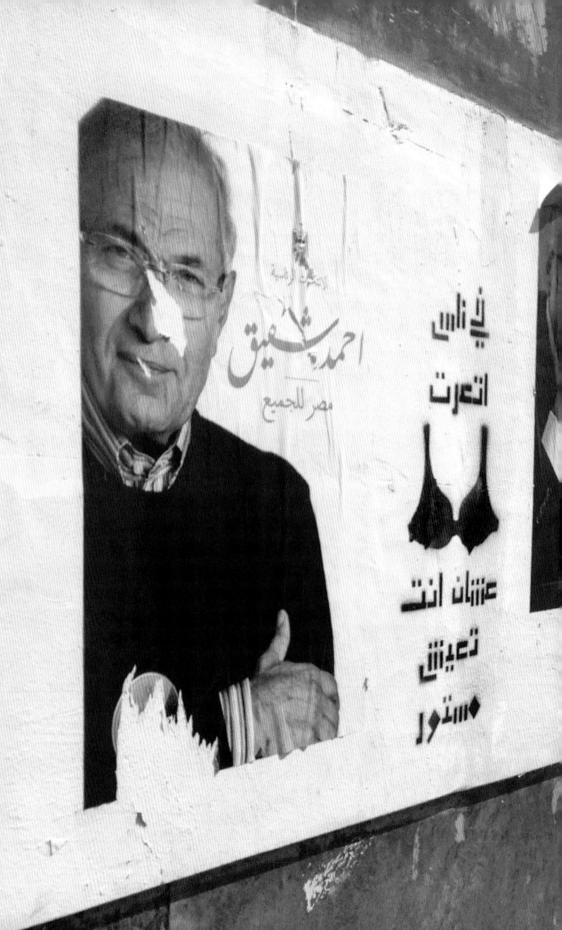

ed a mural under the 6 October Bridge in Zamalek, showing a life-size stencilled military tank, in profile, pointing towards a man on a bicycle carrying a large board on his head loaded with loaves of bread — a bread delivery man such as you might see every day on the streets of Cairo. The image echoes the iconic confrontation of 'Tank Man' in Tiananmen Square in 1989. It juxtaposes the vulnerable provider of basic necessities of life against the huge, faceless power of the state. Even Ganzeer's initial mural was partly a response to what was already there: the part showing the man with the bread tray was painted over an older advertisement written in a classical Arabic script promoting a bodybuilding centre called 'The Kingdom of Heroes'.

The first response to Ganzeer came from the artist Sad Panda, who added a sad panda figure, also in profile, behind the bicyclist facing the tank. The addition of the panda encapsulated the way demonstrations were growing at the time, with more people joining in as demonstrators walked through the streets. For passers-by, the tank came to symbolise authority, and more artists slowly started adding their own contributions to the conversation.

In January 2012, the space around the tank, the bicyclist and the panda were whitewashed and fifteen protestors were added with their arms reaching up to the sky, facing the street, along with some passers-by. The fact that none of the existing elements of the mural were damaged suggests that the artist(s) who painted the protestors may also have whitewashed the wall. They added a slogan too — 'Starting tomorrow I wear a new face, the face of every martyr. I exist.' — written in a modern angular script using the colour blue for the first sentence and red for the words 'martyr' and 'I exist'.

The fifteen protestors were soon painted over and were replaced, perhaps, by the clearest and most striking addition to the tank. Now in front of the tank stood four protesters; two being run over by the tank, while the other two faced the tank, using their arms to try and stop it from advancing. Underneath the tank's tracks ran a river of blood. Mohamed Khaled is cited as the artist who created these additions to the mural.

Previous page:
32. Some people (Series of 5 Stencils), by Bahia Shehab, March 2012

Opposite:
Top
33. Tank vs Bike, by Ganzeer, May 2011

Middle
34. Tank vs Bike + Protestors, by Mohamed Khalid, January 2012

Bottom
35. Whitewash and Tank + Pro-Egyptian and Pro-Army messages painted by the regime affiliates, January 2012

It didn't take long for army loyalists to whitewash this latest contribution to the wall. Ten days later, the blood, martyrs, protestors, bicyclist and panda all disappeared but the image of the tank itself was left intact. The words 'Badr 1' — the name of the group, it turned out, who was behind this latest intervention — and 'Egypt is for Egyptians' were amateurishly sprayed in black on the tank. The same words were sprayed again in black on the wall facing the tank, together with the sentence 'Army and people are one hand' (i.e. united) in red.

The artist Mohamed Khaled was quick to respond. On 23 January 2012, he painted Marshal Mohamed Hussein Tantawi, then Chairman of the Supreme Council of the Armed Forces and thus the interim head of state, over the messages sprayed by Badr 1. Khaled portrayed the Marshal as a monster crouching on all fours with a blood-drenched, lifeless human figure clamped between its teeth. Blood was smeared all over the mon-

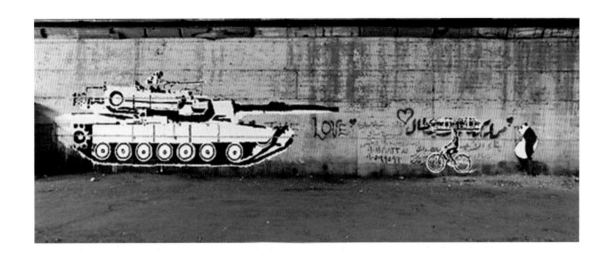

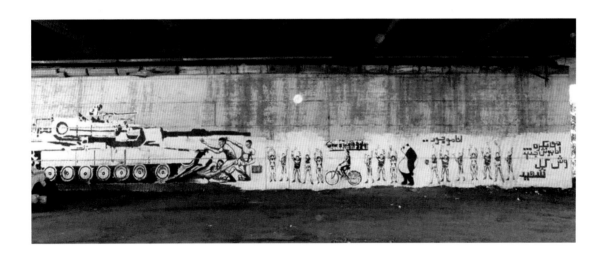

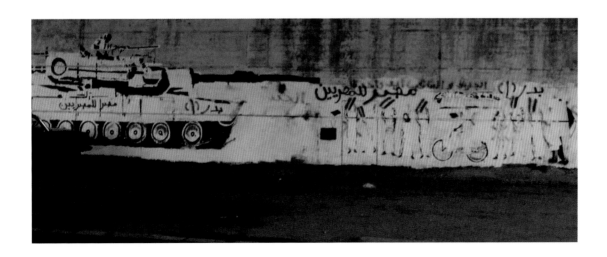

ster's face and formed a red pool beneath the dead figure hanging from its mouth. The Tantawi monster wore a military uniform and a beret with the Egyptian flag's eagle painted on it.

A group calling itself Mona Lisa Brigades soon added more paintings. According to their Facebook page, the group formed on 28 February 2012 to practise contemporary street art. They added a large yellow playing card to the mural in front of the tank, with the figure of Leonardo Da Vinci's Mona Lisa stencilled as a queen wearing black, followed by two images of Mary Mounib, a famous Egyptian film star and comedian of the 1960s, carrying a Kalashnikov and addressing a stencilled head of Marshal Tantawi with her famous line, which translates roughly as 'Don't worry, mummy's boy!' — an interesting deployment of Egyptian pop culture at the height of military rule in Egypt. They also sprayed two stencils of a young martyr, with one of the images flanked by two stencils of Vladimir Lenin raising his fist. Mona Lisa Brigades was using not just local cinematic icons but figures from the wider world in an attempt to translate the Egyptian revolution into a more international discourse. They were clearly striving to communicate the monumentality of what they were experiencing. Another visually interesting addition by Mona Lisa Brigades was a flower with five petals made of stencilled images of Marshal Tantawi's head: three petals in black and two in red (the colours of the Egyptian flag). The group signed its name in Arabic above the stencil of Mona Lisa.

Within a few days, in early February 2012, regime loyalists (presumably) splashed black paint over the face of the Tantawi man-eating monster, leaving his military uniform intact. The rest of the artwork was whitewashed, except that again the tank was preserved. Now the wall had a life-size tank and a crouching body in uniform with a head covered in black paint; everything else was gone. Covering the face of a painted figure is also very common among fundamentalist Islamic groups, who believe that representation of living beings is forbidden in Islam. But I doubt Islamic groups were involved in this instance; whoever defaced the painting wanted to remove the idea of an army marshal as a monster from the picture.

**

After the literal defacing of the Tantawi monster, it now feels like it is my turn to pay tribute to the Tank wall. Until now, I have been working alone on the streets, either going down to spray at four in the morning to avoid harassment or spraying during demonstrations, where I know or hope that the crowd will protect me. But now I want to bomb the Tank vs Bike wall.[7]

A friend of mine knows two young men who want to help; one of them lost his right eye when, like many others, his eye was sniped by the police in Tahrir during the first 18 days of the revolution. We meet at the Bursa (stock exchange) café in downtown Cairo on 4 March 2012. The three of us are very reluctant to reveal our identities: we only know each other by our first names and do not ask any further questions. I have

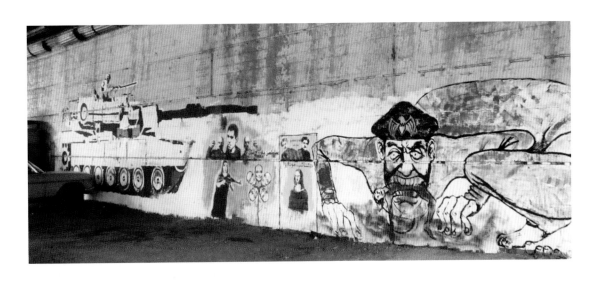

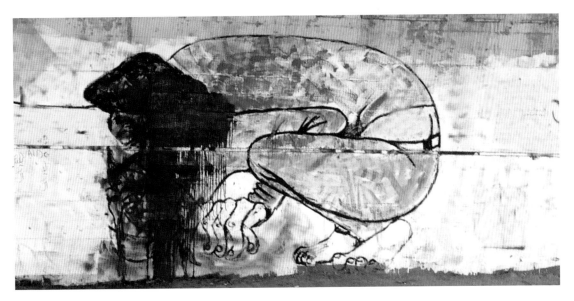

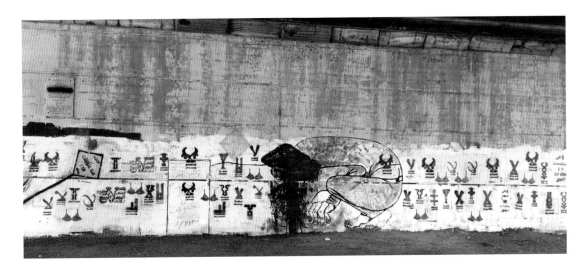

55

a box of spray cans and my folder containing notes on the No campaign, the 'blue bra' stencils, and the 'There are people' campaign. We head to the 6 October Bridge in Zamalek. We spray various stencils 62 times across the wall. It looks great. I need to come back tomorrow morning to take photos in daylight. It takes the three of us around ten minutes to cover the whole wall, then we move out quickly. The next morning, I find a big bus parked in front of the wall, I take close-ups and decide to come back later for a full shot of the wall. While I am creating and spraying new work, I am constantly seeing my previous works being erased. My No stencils in front of the Ministry of the Interior have been mostly painted over. I finally get a good shot of the wall a week later. It looks good and I know that it will be gone soon.

It's 10am on a Friday morning and I go on another spraying spree in Tahrir before the Friday prayer, while everyone is still sleeping. The good thing about spraying on Friday morning and not Thursday night is that I don't need to come back to document my work. I just spray, shoot and leave. I spray on the Syrian tent because they have white plastic and again on the outer gate of the Arab League building. I also really like spraying inside police booths; it feels like I am spraying in a shrine. Nobody sprays inside these booths because people also use them as urinals and they usually stink.

I walk over to Mohammed Mahmoud Street to look at some more beautiful works that I need to document. A long snake with the heads of military generals and military boots and large wings has been painted across the wall after the AUC gate. The lower section of the wall shows a part of another snake with the head of Suzanne Mubarak.

There is a large mural of Sheikh Emad Effat on the wall of the AUC Greek Campus Library. It's simply gorgeous. Ammar is clearly the artist and he must have spent a few weeks painting it, judging by its size. I can see that more of my stencils have been covered. The barrier wall with the large Quran verse has been painted over and a small graffiti underneath the covered-up verse reads 'You've erased the Quran you infidels'. I see two men cleaning the outside walls of a school on Mohammed Mahmoud Street with white paint, and I think how funny this is: here I am with my stencils spraying and there they are with their paint whitewashing. The circle of street-art life.

I decide to design a stencil that reads 'Silmiyya' (Peaceful) to remind us to keep our demonstrations non-violent. I am testing my 'Silmiyya' stencil on the walls in the garden of my house, and Farah is wearing her ballet tutu and dancing with Romel, our dog, on the grass.

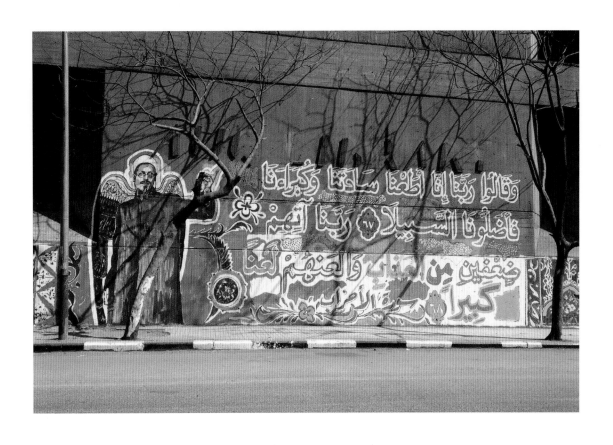

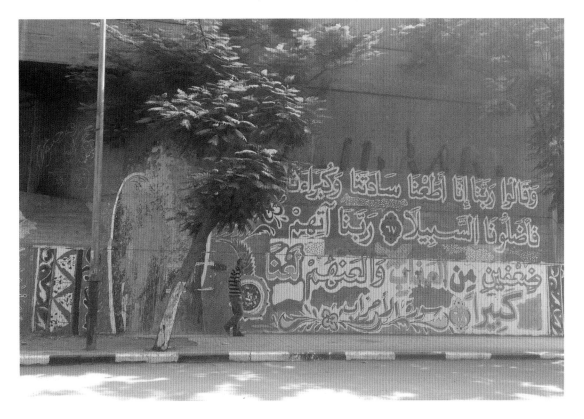

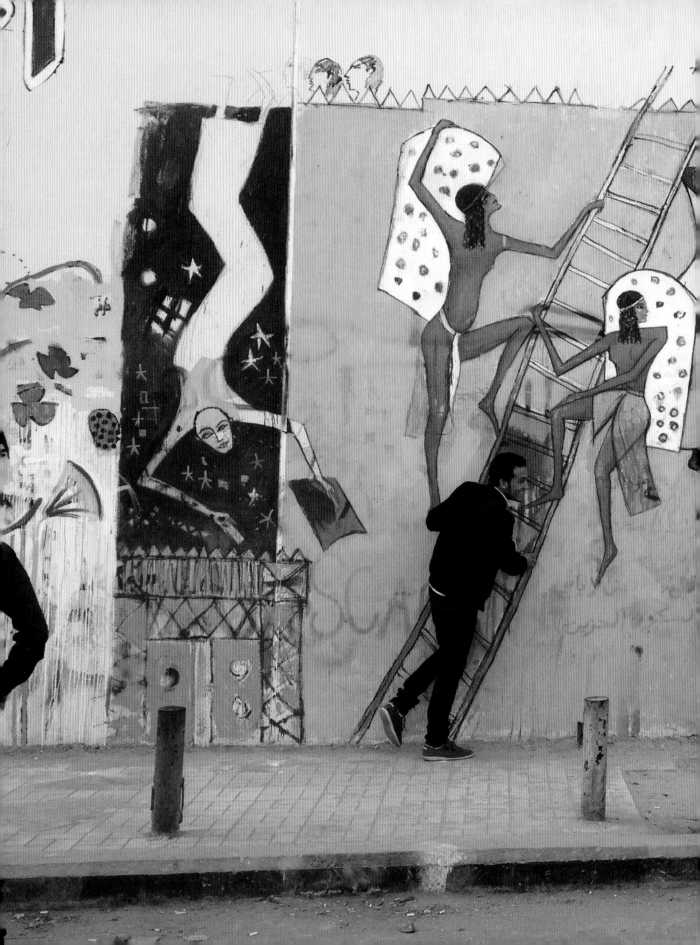

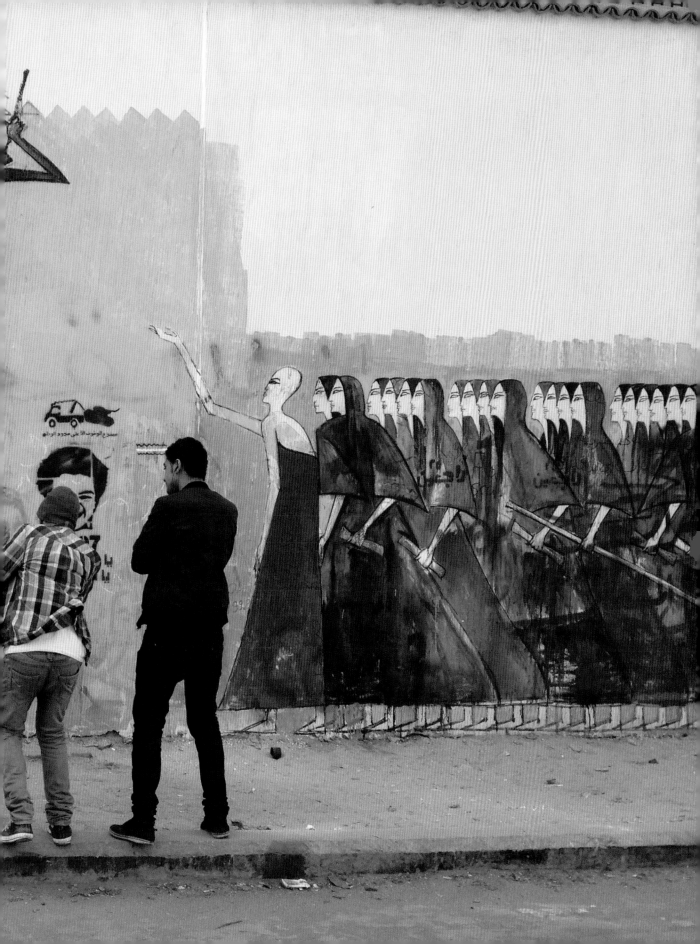

6 The Candidates

March to June 2012

An infographic posted on the 'We are all Khaled Said' Facebook page details the dates and the procedure of the presidential election. I have never seen a detailed infographic of an election process in Arabic before and I soon discover how politically ignorant I am. The page is obviously run by a team of researchers and strategists.

They created a poll to ask their followers who they will vote for, and the results have come out as follows: 30% for Freedom and Justice (the Muslim Brotherhood), 11% for Al-Nour (an ultra-conservative Islamist party), 24% for The Revolution Continues (a left-leaning, mostly secular party), 15% for Al-Wasat (moderate Islamists), and 6% for other smaller parties. On another page an infographic details each presidential candidate and the political party they belong to, divided into four categories: revolutionary, Islamist, couch party (people who didn't join the revolution and do not belong to a political party), and *foloul* (old regime supporters).

The names of presidential candidates have been announced and some of them have already started advertising by hanging posters around town. Scare tactics against the Muslim Brotherhood are surfacing; memes showing women during the Iranian revolution chanting with no headscarves on the streets versus their state now, covered and stoned. Pope Shenouda, the spiritual leader of the Coptic Church, passed away this week and the Salafist members of parliament remained seated when all other members stood up for a minute of silence on the parliament floor to show their respect. The Salafists are not helping their case.

I'm out again to spray my 'There are people' stencil with some friends who said they wanted to tag along. This time we're working in Dokki right next to posters of Ahmed Shafik, the military presidential candidate. A man driving by thinks that we are actually sticking up the Shafik posters and screams at us 'You old regime sons of bitches!', which we all laugh our heads off at.

Next morning, I go back to Dokki to document my work before it disappears. The stencils are too small, I think. I need to cut bigger ones. I try to visit my street artwork whenever I get the chance; it has become a habit, like checking on ill relatives whose death I know is imminent. I always make sure to document the cause of death: was the whole wall painted over or did they target just my artwork? Was it covered by regime sup-

صحية جديدة تضرب مبارك وتفتح الحديث عن ترتيبات الجنازة والدفن

... طرف. برجع إلى السجن في ساعة متأخرة تحسباً لوفاة «الرئيس السجين» .. وسوزان تزور علا .. فقط . والنيابة تحقق في ٦ بلاغات من سجناء ضد التمييز في المعاملة

عمر سليمان في الإمارات بعد عودته من ألمانيا

عكاشة يرد محكمة دعوى مرسي توقف برنامجه

غداً .. محاكمة القضاة المسئولين في «قضاء دار القضاء العالي»

اللواء المرسي : مبارك له الحق في العلاج بأي مستشفى حسب رأي طبيبه

بدء فرز أصوات المغتربين .. ونسبة المشاركة ٤٤٪

المشير تعهد بتأمين مباراة مصر أمام أفريقيا الوسطى

للثورة فن يحكيها .. جرافيتي وتمثيل وأغان

« من فلان الفلاني إلى الثورة تعبت مني يا غالية »

porters or by another artist? I am fine with it if it's done by another artist. It is when it's done by the tools of the regime that I usually plan a counterattack. You can tell it's the regime by the pathetic amount of paint they use to cover the work. The regime and its supporters usually do not bother cleaning the whole wall or even paint it in the same colour. Sometimes the artwork is covered with dust and it's Mother Nature proving that she is more powerful and permanent than paint. But I am not that lucky yet. None of my artworks have survived that long.

In Dokki, my 'There are people' campaign is erased three days after we sprayed it. So I spray it again the following month, this time with bigger images and a clearer text. Two weeks later somebody takes a photo of my stencils, citing the artist as 'anonymous' and shares them online. They go viral. Three weeks after that, they feature on the third page of one of *Al-Shorouk* newspapers, right under the image of Mubarak in a hospital bed. The message has surpassed the medium; I feel like maybe we are getting somewhere.

<p style="text-align:center">**</p>

Another Friday morning, another chance to spray. On my way back I change my clothes in the car and pay a quick visit to the Islamic Museum to study some Fatimid art for my PhD. There's a lot to document and I need to shoot the two beautiful wooden mihrabs of Sayyida Nafisa and Sayyida Ruqayya. I spend two hours documenting every single word written on the mihrabs in detail.

Presidential posters are everywhere on the street. It is so exciting to see this display of democracy, maybe for the first time in my life, for a presidential candidate in my part of the world. Billboards that I can spot on my way to work are set up for: Amr Moussa, Abdel Moneim Aboul Fotouh, Mohamed Morsi, Mohammad Salim Al-Awa, Ahmed Shafik and Hamdeen Sabahi.

One online poll is suggesting that Amr Moussa (a secularist liberal who was formerly Secretary General of the Arab League) will get 50% of the votes. Aboul Fotouh (a former leader of the Muslim Brotherhood now running as an independent Islamist) and Sabahi (a veteran activist against Sadat and Mubarak and now a liberal secular candidate) are getting the highest votes among Egyptians abroad, with Amr Moussa coming in third. But this is all unverified information that I cannot fully trust. Aboul Fotouh's official page puts him in first place followed by Mohamed Morsi (of the Muslim Brotherhood), then Khaled Ali (a liberal lawyer and opposition campaigner).

A poster of Ahmed Shafik, another candidate and until recently the Prime Minister under Mubarak, has been doctored to put the face of Mubarak in place of Shafik's and a new slogan has been added: 'To realise the aims of the revolution.' People are sharing photos of Muslim Brotherhood election food packages on the internet. Votes are being bought with a box of kitchen staples. They are distributing everything: rice, cooking oil and meat. So much is happening that I can barely keep track. But all this is healthy. If we want a democracy, we need to learn how to listen to each other.

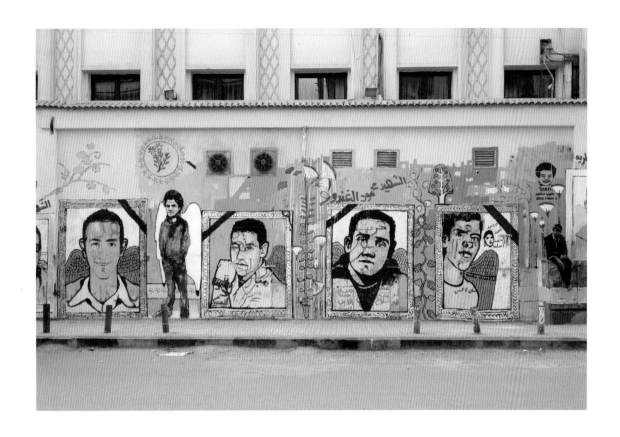

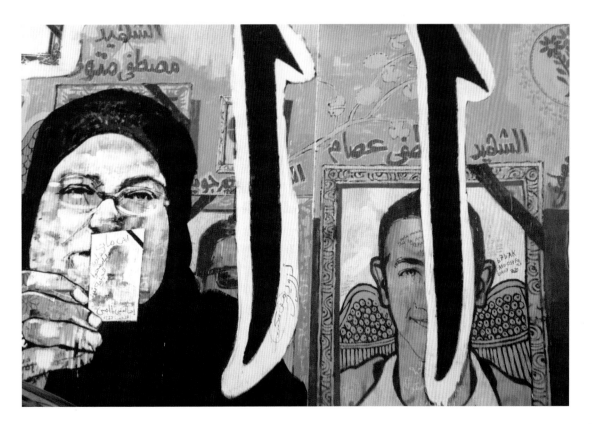

**

23 May 2012. Election day is here, and Google is celebrating it with a special 'doodle'. I log into the election website to check my election station and it turns out to be across the street from my mother-in-law's house in Zamalek, on the campus of the Fine Arts school. I go in the morning to stand in a line, that extends around the corner of the street, to vote for the first time in my life. My daughters are sitting on the sidewalk. They are hungry and thirsty. I didn't know it could take this long. By noon, the girls are very tired so I take them to their grandmother's house nearby and we wait until later, in the hope that the queue will be gone by nightfall.

It's 8pm and I'm back at the voting station. As expected, we go in very quickly. On the ballot sheet there are 13 candidates, each with their name, their symbol and their picture. Voting designed for the illiterate. I tick a box, drop my vote in the ballot box, dip my finger in the fluorescent ink and show it to the girls, who rub some of my ink on their fingers. We take a photo of our three ink-stained fingers as a memory. I am glad I am sharing all these monumental events with them, even though I know they may not remember any of this later on.

Below
45. 'Forget about the martyrs and focus on the elections,' Mohammed Mahmoud street, Cairo, Egypt, by Ammar Abo-Bakr, May 2012

**

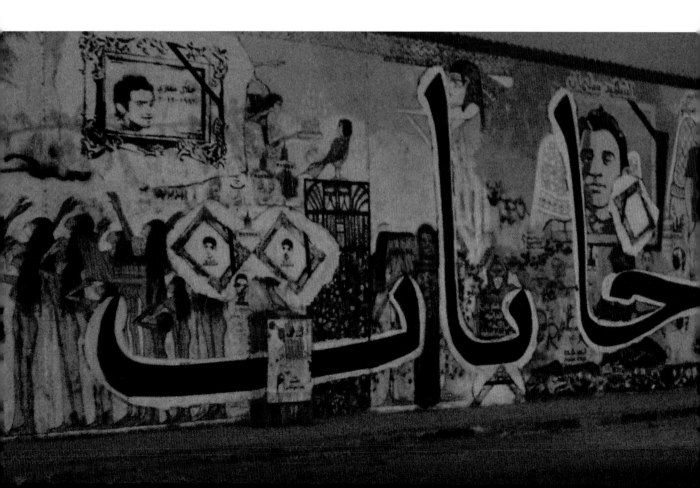

It's 28 May and the results are in. It's going to be a run-off between Morsi and Shafik. I am outraged at how naive I was to think anyone else could have been elected. Ahmed Shafik and Mohamed Morsi are officially the finalists in the first 'democratic' presidential elections in Egypt. Shafik belongs to Mubarak's old regime and Morsi belongs to the Muslim Brotherhood. They are the only candidates with organised grassroots outreach. One has all the governmental institutions and the old regime supporting him, and the other has the support of all the religious institutions and the benefit of years of underground organisation by the Brotherhood.

Neither candidate represents the aspirations of the revolution.

I walk down to Mohammad Mahmoud Street in Tahrir to pay tribute to the portraits of the martyrs that are painted on the AUC walls in downtown. I discover a huge mural by Ammar Abo-Bakr lamenting the results of the elections. He must have worked all through the night. Ammar has painted portraits of the mothers of martyrs over the large-scale portraits of the martyrs. And he has defaced his own work with a large slogan: 'Focus on the elections and forget about the martyrs.'

I grab my 'No to a new Pharaoh' stencil and I spray it on his wall over and over and over again.

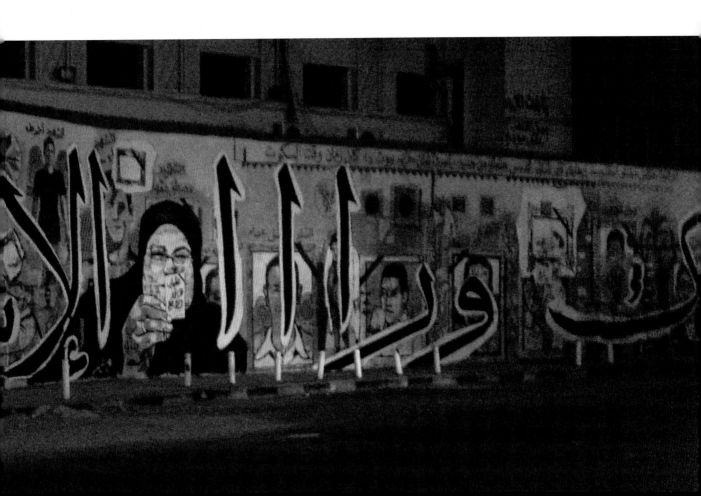

I sit on the sidewalk across the street from our main campus facing Ammar's wall and I begin to sob. His work confirms my feeling that we have lost. It is five in the morning when I see his work, and now I cry for half an hour on the street. I know that we are connected. I have never met him in my life, but clearly when the result was announced we all hit the streets at the same time to protest for the same reason, without any previous plan. This is the mass subconscious that everyone keeps talking about. I am living it and it is painful and beautiful at the same time.

**

Morsi or Shafik. This is the choice before us.

In an informal housing area, a calligrapher has hung a banner of white cloth with the words: 'The difference between Morsi and Shafik is the difference between a catastrophe and a black catastrophe.' The *Dostour* newspaper has the headline: 'The Brotherhood holocaust: the revolutionary guard and veiled militias who opened the prisons and burnt police departments on 28 January are ready to burn down the country again.' The headline is accompanied by two images of veiled and armed men marching. As for Shafik, revolutionary groups are warning that Mubarak will be out of prison if he wins the elections.

We learned some great lessons from this election. We learned that our actions on the streets are not reflected on the ballots, and that until we organise ourselves we will not be able to take this country to the better place we want it to be. We are taking baby steps towards a new future, but the most important part of this whole process is that we learn. Whoever wins this election, it is certain that neither candidate represents me.

On a not-so-busy Friday afternoon, I choose to go down to spray my 'No to a new Pharaoh' again. (This 'no' comes from a mosque, the Masjid-i-Haydariya in Qazvin, Iran: the original 'no' was moulded in stucco [600H / 1200CE].) I am placing my stencil on a wall in Tahrir when I hear two men shouting. They are both bearded and one has a shaved head. I realise that they are screaming at me, so I start running. They chase me from the vicinity of the museum to the gate of the AUC. They are cursing in the foulest language. I rush through the gate of the university screaming 'Faculty, faculty!' with my hands up and the security guards let me through. I throw my cans in the bin and rush to the fountain area. The two men obviously cannot come through, but I keep checking and they are still waiting for me at the gate. An hour passes before they finally decide to leave. I will stick to my nightly downtown visits from now on.

On 1 June 2012, the emergency law is fully lifted in Egypt for the first time since 22 December 1981. The following day, Mubarak and his Minister of the Interior, Habib el-Adly, both receive sentences of life in prison, but his sons Alaa and Gamal are acquitted of corruption charges. Protests fill the streets as Hosni Mubarak is flown to prison right after the trial.

Opposite:
46. 'No to a new Pharaoh',
Mohammed Mahmoud
street, Cairo, Egypt, by
Bahia Shehab, May 2012

There is a very telling cartoon drawing on social media showing the head of Mubarak in jail while his body, which carries a sign that reads 'Mubarak's Regime', walks free holding a piece of paper that reads 'innocent'. This summarises where we really are now: getting rid of the leaders of the regime doesn't mean that the deeply rooted system is gone. Mohamed Gaber, the artist responsible for the iconic 'Be with the revolution' design, has painted the words 'Opening soon' in large green script on the wall outside the burnt building of the dismantled National Party. He is predicting that the military will return, represented by Shafik, and the old regime will be restored.

The April 6 Youth Movement has issued a statement that the revolution continues.

**

June 2012. I applied for a TED fellowship last year and then completely forgot about it. After two rounds of video interviews I was told in February that my application has been accepted. I read the email on my phone first thing in the morning with one eye half opened and ended up jumping up and down on my bed.

Now, after many preparation meetings, I am ready to go to Edinburgh for TED's Radical Openness conference. I have been revising my talk in my head over and over again till I can recite it in my sleep. I am very nervous, as I know the repercussions could be grave for what I am about to do. Activists are being detained randomly and face severe consequences for speaking up. I need a break from the election news overload. I am also happy that I will be out of the country and I won't have to vote for either candidate. In any case, I wouldn't have voted if I were in the country.

I give my TED talk to a standing ovation. It is very hard for me not to cry as I am delivering it. I practised my talk a hundred times and now I know it by heart. I am just the messenger here and I am humbled by the fact that I have the privilege to tell the story of Tahrir on a major world stage like TED. I am fascinated by how beautiful Edinburgh is.

Back home the military is deployed on the streets everywhere in anticipation of the announcement of the presidential election result. My friends are posting their thoughts and I am rolling on the ground with laughter. Stress brings out the comic gene in Egyptians; anxiety is confronted with humour. I keep refreshing my newsfeed every five minutes. My favourite post is: 'OMG!! Which emasculated president with no powers will we have??? OMG!!! OMG!!' It reminds me of the day Mubarak stepped down and all the jokes about the 'Man behind Omar Suleiman'.

There seems to be a problem with the numbers. A recount of votes has been ordered. The wait for the announcement is gruelling. Now the announcer is reading out the numbers of votes in every governorate in a very slow, monotonous voice. After the recount, Mohamed Morsi is declared the new president of the Arab Republic of Egypt. I break down in tears. I am here in Edinburgh putting my life in danger to tell the story

of the revolution and a new president has just been elected. I'm scared and excited and hopeful that at least it is finally not a military man running the country. The Muslim Brotherhood supporters start flooding Tahrir Square. It's theirs tonight.

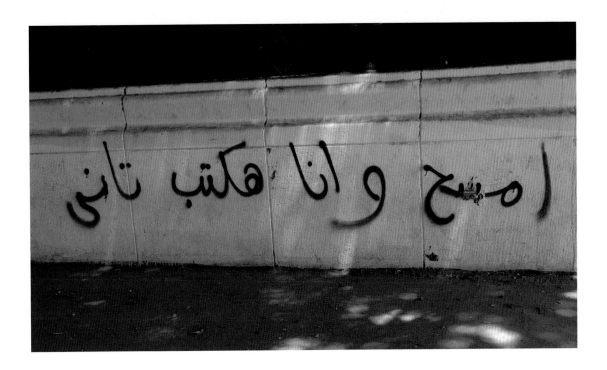

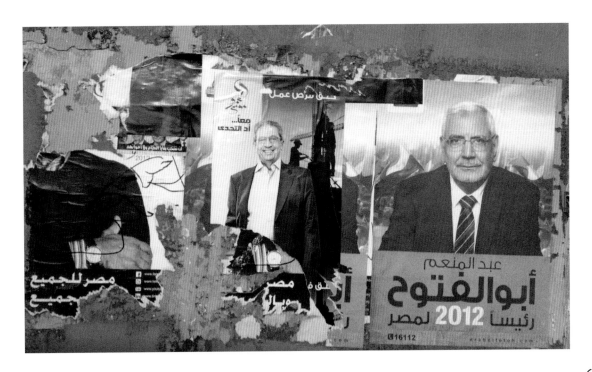

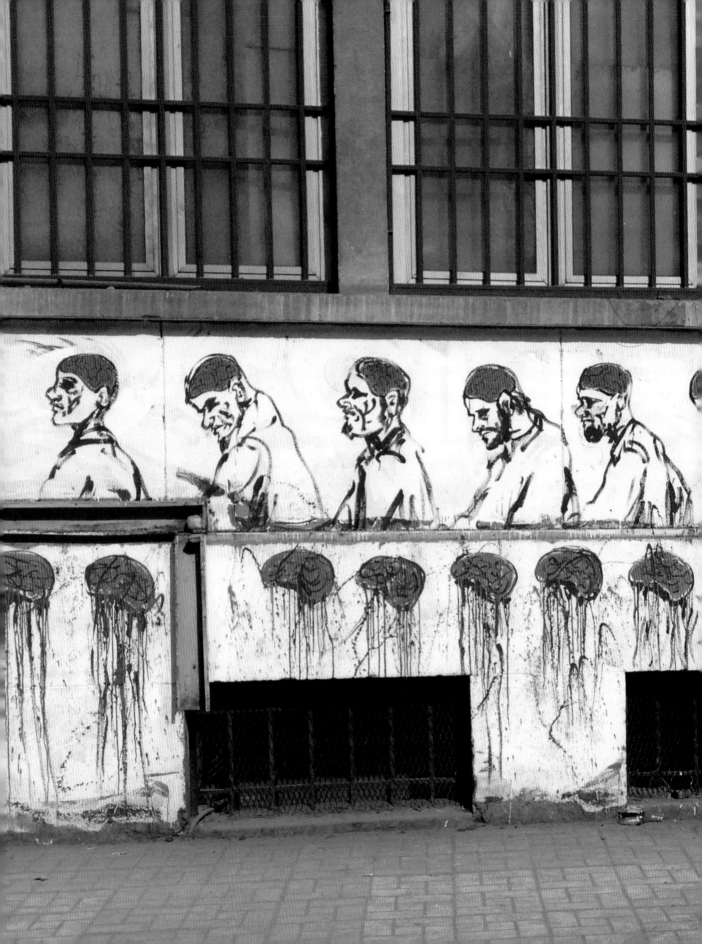

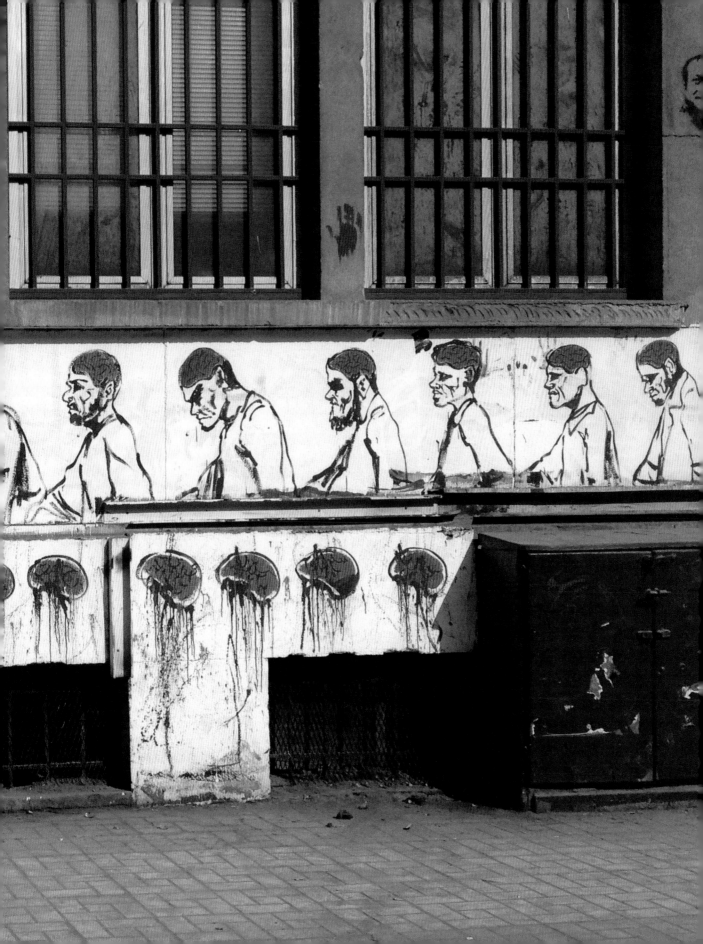

7
The New Pharaoh

July to December 2012

I am still going to Tahrir to spray, but now one of the people who joined me took my number and has been asking me to call him whenever I need help spraying. He asks me to meet him at the police club. His questions were always very weird, but a date at the police club is just a bit too obvious! I will play along. My daughter Farah is with me. She enjoys looking at all the paintings on Mohammed Mahmoud Street where Ammar has painted some empty picture frames on his mural on the wall of the AUC, and people are putting posters of dead martyrs inside them. She is playing with my phone, taking lots of photos of my new 'friend'. I think after seeing me with her, he is convinced I am harmless. I assure him that I need his help and that I will call him whenever I am spraying. We part at that.

I go on another street art documentation spree because the revolutionaries are pulling down some of the barrier walls in Tahrir. The concrete blocks that form the wall on Sheikh Rayhan Street have been pushed over. They still block the street, but they are scattered over the asphalt, as if hit by a bomb. I take more photos of my artwork and the work of others and I head back home.

I do not feel like I need to be on the streets in Cairo now that we have an officially elected president. I want to bid the streets farewell. I choose a street that leads out of Tahrir Square and I write a message on the asphalt, in front of the speed bump: 'Beware of Speed Bumps.' After the bump, I write: 'Long live the revolution.' To the taxi drivers — who are thanking me for highlighting the problem at 4 in the morning during Ramadan — I am simply doing the work the government should be doing by pointing out a speed bump on a busy street. But someone with more insight will understand that what I am saying is for us as people leaving Tahrir Square and heading towards a new phase of the revolution: we need to be aware of speed bumps and keep the main aims of the revolution very clear in our minds. Two people help me with writing in the middle of the street. One is a kind artist who volunteered and the other is my tail. I have discovered that it is safer to work with him than without him. So I say goodbye to art on the streets of Cairo.

**

No sooner have the revolutionaries pulled down the barrier walls that the regime builds new ones. There are now twelve walls in Tahrir.

Previous Page:
49. 'Brain Damage'
depicting the effect of
the Muslim Brotherhood
on its members,
Mohammed Mahmoud
street, Cairo, Egypt, by
Mohammed Khaled,
November 2012

Opposite:
Top
50. 'Beware of speed
bumps', by Bahia Shehab,
August 2012

Bottom
51. 'Long live the
revolution', by Bahia
Shehab, August 2012

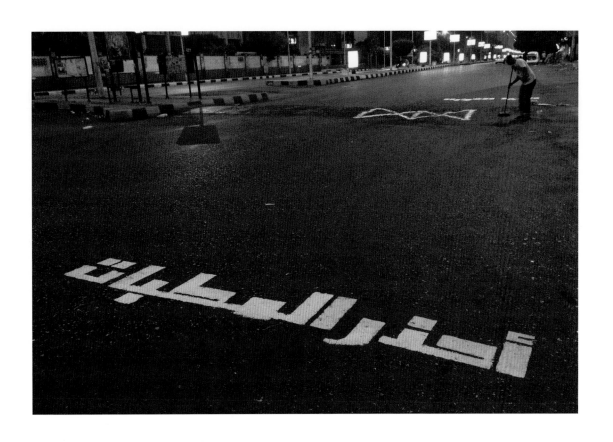

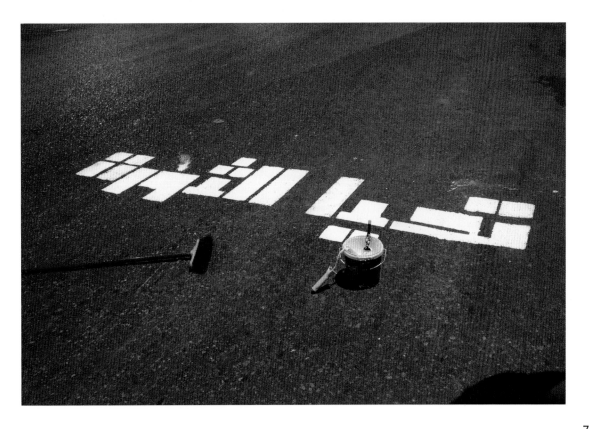

Veiled women are starting to appear on TV, and EgyptAir now has veiled air hostesses. Policemen are wearing their beards long. Hate speech against the Copts is intensifying online and on the street. Two niqabi women attacked a Coptic schoolgirl on the metro and cut her long braid; there are images of her, wearing a school uniform and looking at the camera, sitting in her house and holding her cut braid in her hand. The pain on her face is palpable.

There is a powerful meme about a poor man eating rubbish with a speech bubble that reads: 'I wish they would ban bikinis.' Underneath him are two beggar children. One is asking: 'Do you think they will allow officers to grow their beards?', and the other child replies: 'The most important thing is for them to allow TV presenters to wear a veil.'

At the same time, two Muslim Brotherhood Sheikhs, Mohammed Jibril and Rajab Zaki, have called for a march of millions to Tahrir Square in support of the president's decisions. They are asking people to do a complete reading of the Quran together. Usually this is done to gain blessings, most commonly by the relatives of someone who has died. They gather to read the Quran in its entirety to ensure a merciful exit for the soul of the deceased. According to the website *al-Masry al-Youm*, President Morsi is issuing a pardon for all prisoners detained for their involvement in the revolution since January 2011. His regime is trying to demonstrate its accomplishments.

**

My TED talk has been launched online and I am bracing myself for the worst. I am officially out as a street artist supporting the revolution. I don't know what to expect. All my friends are sharing my talk online with pride. I can't celebrate; I feel like I could get a knock on my door any minute and my whole existence could be endangered or transformed in a moment. But I always knew this was a risk. There is no turning back now.

**

On 17 November 2012, in a village in Asyut, a train crashes into a school bus killing dozens of children. President Morsi's Twitter account issues an apology to the families of the victims, accepting the resignation of the Minister for Transport, and calls for immediate investigation.

The photo of four of the children in their white shrouds is haunting me. A post listing their names makes it clear that the dead included sisters and brothers from the same family. Amr Adeeb, a TV host and mouthpiece for the old regime, calls on the president to step down. These kinds of accidents have always been brushed aside as random acts of chance. The families of the children are compensated financially. People are sharing cartoons of the dead children, portraying them as angels flying to heaven.

The details of this incident posted on social media are too vivid in my mind. Here is a video of a regretful father who, when asked about the last thing he said to his son

before he got on the bus, cries bitterly and says that he hit his son so that he would not miss the bus. Another video shows one of the survivors, a girl only nine years of age, being asked what message she has for the government. She calmly replies: 'You are all dogs.' A note circulates online comparing the compensation the government pays to the families of the dead with other more expensive items: a new iPhone, 9,000 Egyptian pounds; a calf, 6,000; a cow, 10,000; a Mercedes Benz headlight, 5,000 — an Egyptian child, 4,000.

**

On 22 November, Morsi unilaterally expands his powers, giving his decisions immunity from judicial review and barring the courts from dissolving the Constituent Assembly and the Upper House of parliament. Mass protests against Morsi's 'constitutional decree' begin almost immediately, as well as counter-demonstrations by his supporters.

After the summer election, I said farewell to spraying messages on the streets of Cairo. But I have had enough. Morsi has given himself the powers of a new dictator and he deserves one of my Nos with flying colours. I spray this message on one of the roads leading into Tahrir Square: 'We are back. No to a new Pharaoh. No to Morsi.'

After this No, I go through the remaining 970 Nos in my book. I know I will need them in the days, months, and years to come. I know I have more than enough ammunition.

The discontent with Morsi continues to grow. Mohamed ElBaradei makes a strong statement in Tahrir denouncing the Brotherhood's new constitution, calling for everyone to collaborate on a peaceful solution. Artists record a video shot in dramatic black and white of celebrities, actors and actresses, public figures, scientists and politicians rejecting the constitution.

I have downloaded a copy of Morsi's new constitution. It's the first time I read a constitution. Why didn't we study this at school? Every citizen should read the constitution. I find a spelling mistake in the third article and stop reading.

The revolutionaries are circulating their own meme about the constitutional referendum, with a green circle that reads 'agree' and a black circle that reads 'infidel'.

**

I have been going to Tahrir more and more often. Large flags of the martyrs are flying, the crowds are out and I am spraying all my stencils around Mohammed Mahmoud Street and Tahrir Square.

There is a profusion of images. Here are three devils beating the blue-bra woman. Ammar has painted more large-scale paintings of martyrs as saints on the Mohammed Mahmoud wall. Nearby, a large yellow banner hanging on the street sign on Mohammed Mahmoud reads: 'Brotherhood is not allowed entry.'

I spray on Fridays during demonstrations and at night during the week. My husband is concerned but he does not stop me. One evening in November he finally voices his concern: 'Be careful: they will catch you.' I reply jokingly: 'Make sure to bring my *halawa* with pistachios.' *Halawa* is a staple food for prisoners. I go back to Tahrir to document my work as usual. Last night it didn't feel safe for me to do so. I am starting to feel the danger, but I can't stop. A video of a gang of men stripping a woman in Tahrir and raping her in plain sight has surfaced. These are organised gangs targeting women of all ages. As if killing us was not enough. But I guess the tactic is to kill the men and break the women so that we keep quiet and keep living with our shame. They want to scare us out of the square. Historically, rape has always been used as a weapon of war and now the same is happening in our city.

<p style="text-align:center">**</p>

December 2012. There have been calls for mass disobedience. Pictures of the demonstrations are intimidating; tens of thousands of people are filling the streets. Artists are painting on the walls outside the Al-Ittihadiya presidential palace. I'm dying to go there and spray, but it is too dangerous. The president is said to have run away through the palace's back door. The Muslim Brotherhood claims that there were 2,000 protesters outside the palace, but a phone company states that there were 700,000 phone signals. Both numbers are from a meme, so there are no confirmed sources yet.

Two veiled women carry signs. One reads: 'By Allah we are Muslims and we refuse the Muslim Brotherhood rule.' The other reads: 'They say that a woman's voice is *'awra*[8] but it is a *thawra* (revolution)', referring to the Islamic idea of those parts of the body which are meant to be concealed.

Aliaa Elmahdy has stripped naked with Femen protesters outside the Egyptian embassy in Stockholm, carrying an Egyptian flag with the words 'sharia is not constitution', wearing only a plastic flower wreath on her head and black stockings. She sought asylum in Sweden after she started getting death threats for posting her naked photo on her blog in October 2011. She declared that the revolution was also a call for the liberation of women from society. Her image received 2 million views, probably from men who want to see a naked body, but her real intention was to denounce oppression against women.

Nile TV reporter Hala Fahmy is attacking President Morsi while carrying her shroud live on air, declaring that she is willing to die. She is interviewed the next day by the old regime mouthpiece Amr Adeeb.

There is video of machine guns being used outside the palace. Revolutionary webpages are reporting that Muslim Brotherhood supporters are attacking protesters. Five killed and 350 injured.

There is more and more fake news: photos of people being injured and killed, that look clearly like they were taken in other countries, are being shared as if they were from the demonstrations last night. People are increasingly uncovering deceptions. Photos from Afghanistan or Iraq are circulating on social media, labelled as proof of Muslim Brotherhood violence. As the prices of basic goods rise, people claim — falsely — that trading these goods are the main businesses of Muslim Brotherhood members. There are calls for boycotting the products of Muslim Brotherhood companies, and there is a list of all the supermarkets and outlets owned by leading figures in the Brotherhood and their supporters.

In December, I hear a chant from the demonstrations: 'It is said, and it should be said, that once upon a time our brothers, your children, started a revolution that was like a volcano. The military came, rode over it and took its eyes out and made a pact with the Brothers. And neither can be trusted, the rule of the military and the Brotherhood.'

Al-Dostour political party has just released the route of its planned marches for this Friday, 7 December, after the prayer. Morsi supporters are calling for counter-demonstrations and revolutionary webpages are warning of more bloodshed.

Déjà vu: an image of a tank with the words 'Down with Morsi' sprayed on it. Only a few months ago, a tank was graffitied with the words 'Down with Mubarak'. The person sharing the picture has added the caption: 'Take two: why can't we seem to hang on to a president?'

Someone has set fire to the Muslim Brotherhood headquarters in Moqattam. The Brotherhood is instructing all its headquarters to close.

I feel that online and offline wars are taking place in parallel universes. Fake news and fake posts are being shared on social media, and I don't know who and what to believe anymore. Muslim Brotherhood pages claim there are armed thugs among the protesters. Revolutionary pages share images of protesters praying. Both things could be happening in the same place and I know that it all depends on who is holding the camera and where they are pointing it. It is evident that there are factions and divisions within all governmental institutions, and not just on the streets. There are digital initiatives to expose supporters of the old regime and the Muslim Brotherhood alike. As if the country is now divided into two camps and each is set on denouncing members of the opposite camp. It's like watching a game of tennis.

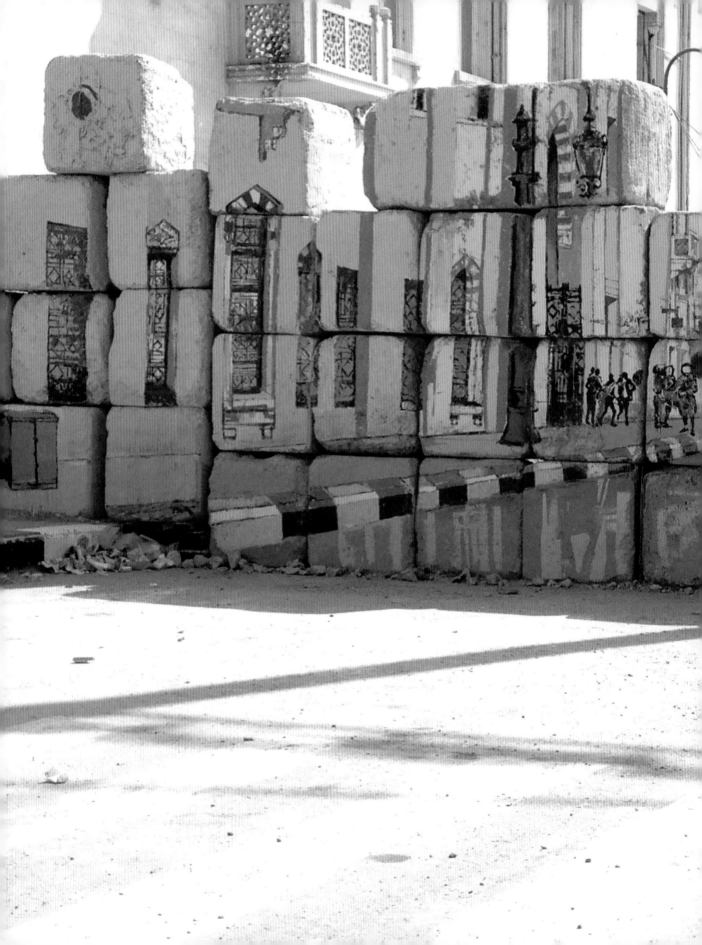

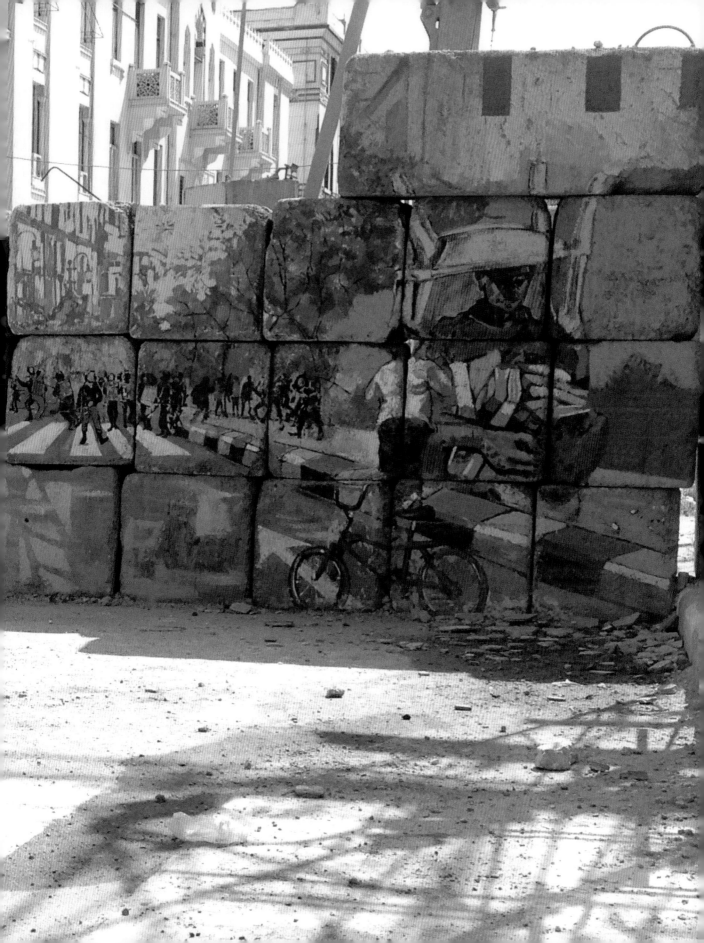

The Children of Asyut

January to June 2013

In Lebanon, during the war, parties were affiliated with armed militias. So we stayed away from politics. But here in Egypt the images and sounds in my newsfeed have recruited me to the revolution. Now I watch what is happening in my adoptive homeland and I fear it might escalate into a civil war. I worry my daughters will have to live through the same nightmare I experienced in Beirut.

I spray messages and images on the streets of Cairo because I want my daughters and my students and their children to live in a better country. I want them to find happiness here and not seek it abroad because their government is corrupt, incompetent and cruel. For the sake of this idea, I am willing to face whatever fate decides to throw my way.

But two years into the revolution our dreams of a better future are no closer to reality. On the streets they still chant for 'Bread, freedom and social justice'. We do not feel safe. The money stolen from the state has not been returned. There is no youth employment and incomes for everyone remain desperately low. People injured in the revolution get no support. We still don't have affordable healthcare. Meanwhile the list of freed culprits from the old regime grows longer and longer.

Previous:
53.Trompe-l'œil on barrier wall on Sheikh Rihan street, downtown Cairo, by Ammar Abo-Bakr, Mohamed Elmoshir, Layla, Hanna El Degham, March 2012

Opposite:
Top
54. 'Children of Asyut' (series of two stencils in 52 names), on the outside walls of the burnt down former National Party headquarter in downtown Cairo, January–March 2013
Child 1: 'They still didn't get the lesson.'
Child 2: 'No.'
Child 3: 'It's okay, repetition is the best teacher.'

Bottom
55. 'Children of Asyut', Zamalek, Cairo, January–March 2013
Girl: 'Mother is on the way.'
Her brother asks: 'Soon?'

**

Calls have gone out for mass protests on 25 January to mark the second anniversary of the revolution. Peaceful protestors are organising 'No to military trials' human chains on the streets of cities all over Egypt. Protestors wear yellow stickers with the words 'No to military trials' over their mouths.

I want to mark the occasion with a new street campaign. I can find nothing more fitting than the Children of Asyut — the children who were killed when a train crashed into their school bus in November 2012. Every detail of that accident is painful to me; it encapsulates our failure to protect our most precious and most vulnerable assets. As a mother, the fate of the mothers who lost their children resonates with me. Compiling a list of names of the children seals the deal in my mind: I have to paint them. To me these children were killed by a corrupt system of governance. We started a revolution so that accidents like this would never happen again. I wanted in some way to bring the children back to life.

On 25 January 2013, I start painting the children of Asyut on the walls of Cairo. Different reports give different numbers, but I have managed to identify 51 dead children. I have collected their names and then grouped them into boys, girls and families. I want to paint sisters and brothers in the same place — so they can come to life again on the streets of Cairo, together. I paint each child walking on railway tracks with a speech bubble above her or his head. Inside each bubble I imagine their dreams, their questions, their wishes. The children are sprayed in black, but their thoughts are painted in colour.

Each painting is specific to where it is placed in the city. I paint one girl saying 'I went to heaven and they are all going to hell' on the fence outside the burnt down building of the ex-ruling National Party in downtown Cairo. On the same wall I paint three brothers killed on the same bus. They have a brief conversation:

Child 1: 'They still didn't get the lesson.'
Child 2: 'No.'
Child 3: 'It's okay, repetition is the best teacher.'

On a fence in the Dokki district of Giza City, near where a green plate reads 'Land owned by Princess Noura Al Saud, Giza-Cairo', I paint a little girl saying: 'I wish I'd grown up to be a princess.' Near a large, hand-painted advertisement in Mohandiseen for police recruitment another child appears alone with the statement: 'I could have grown up to be a policeman or a scientist.' Near a bus stop in Zamalek, a sister calms her brother by saying: 'Mother is on the way.' Her brother asks: 'Soon?' Across the street from them, next to a notice calling for the responsible use of firecrackers during Eid to safeguard children's eyes, I spray another child. The notice reads: 'The eye of a child is precious.' I paint a child from Asyut saying: 'The life of a child is also precious.'

My favourite intervention is on a barrier wall in front of the Ministry of the Interior in

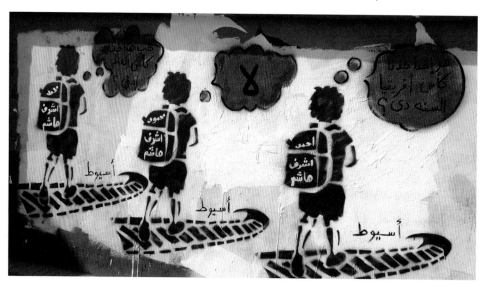

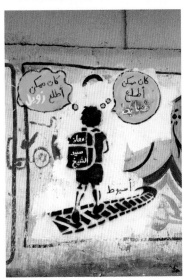

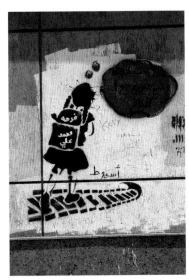
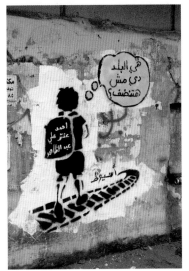
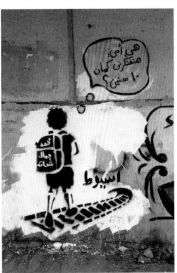

downtown Cairo. This barrier wall has a special place in my heart. On 15 February 2012, it became the first full wall I graffitied, with my 'A thousand times No'. A month later, another group of artists covered my Nos with a *trompe l'oeil* image showing the street perspective beyond the barrier (including the Ministry of the Interior), as if the barrier did not exist. They called the campaign 'There are no walls'. They added a unique symbol of Arab and particularly Palestinian resistance, Handala. Handala, a child forever 10 years old, often shown stubbornly turning his back on the viewer, was originally drawn by Naji al-Ali, a Palestinian cartoonist who would later be assassinated in London in 1987. Finding Handala carrying a sword on my wall is like finding an old friend.

A year later, I am back at the same wall. Though the artists painted the barrier to pretend that 'There are no walls', the walls are still there. I decide to add my children alongside Handala, with their questions and their dreams. I paint eight children playing hide and seek in this imaginary street:

Child 1: '*Khalawees?*' (Ready? Have you hidden?)
Child 2: 'Not yet.'

Bottom
66. Handala on barrier wall, Fahmy street, downtown Cairo, by Hossam and Team, March 2012

Opposite:
Top
67. Rainbow on barrier wall, Fahmy street, downtown Cairo, by El Zeft and Nazeer, March 2012

Second from top
68. Ship portholes on barrier wall, Falaki Street, downtown Cairo, by Abdulrahman and Shaimaa, March 2012

Third from top
69. Man and child, Yousef El Guindy street, downtown Cairo, by Salma el Tarazi and Team, March 2012

Bottom
70. Mural inspired by *Description de l'Égypte* Kasr El-Aini street, downtown Cairo, by Alaa Awad, March 2012

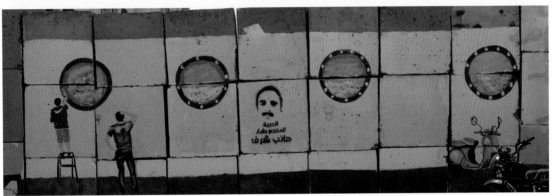

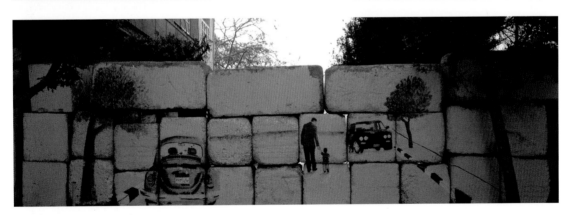

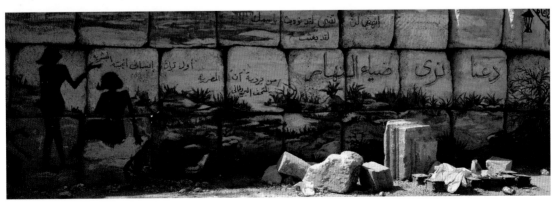

Child 3: 'Has the revolution succeeded?'
Child 4: 'Not yet.'
Child 5: 'Did we get the rights of the martyrs?'
Child 6: 'Not yet.'
Child 7: 'Has Egypt become heaven on earth?'
Child 8: 'Not yet.'

I keep to my tried and tested routine, paint during demonstrations or at dawn, move fast, spray faster, and answer to no one. I also make sure to never leave my house without my favourite heart-shaped carpet beater. I bought it on Mohammed Mahmoud Street last year after I was chased. I can justify it to anyone because it seems useful. I'll say that I brought it to clean my rugs and left it in my car. I love this stick because it is made out of twisted bamboo, like the beater my grandmother used on her carpets when she laid them on her balcony in the sun. When you move the beater in the air it makes a swooshing sound. In a confrontation the sound is a good signal that if this touches you it's going to hurt. I've had pedestrians cross to the other side of the street when I'm carelessly swinging my beater as I examine a wall. I might look small, but I'm not harmless. Luckily, I've never had to use it except on carpets.

I can sense the increased tension and unease of people on the streets. On 25 January 2013, the second anniversary of the revolution, while I am spraying the Children of Asyut off Mohammed Mahmoud Street, nearby police are brutalising and gassing protestors in Tahrir, as if it is 2011 all over again. Violence breaks out across the country and citizens and police are killed during demonstrations in Cairo, Port Said and other cities. The president's tweets offering condolences and promising to find the culprits are flying around on social networks with sceptical comments attached.

In Tahrir, there is a graffiti of the famous *Al-Ahram* newspaper headline from the night of Mubarak's resignation, complete with the *Al-Ahram* logo. The headline's message has been negated: 'The people have not overthrown the regime.'

The crackdown on activists continues unabated. In late March, Alaa Abd El-Fattah, blogger and political activist, is arrested along with five others. In early April, revolutionary rapper Islam Abdel Hafez is detained. The 'We are all Khaled Said' Facebook page is reminding people that no one has the right to take them into police custody without a warrant. It is painful for me to witness all this injustice.

I keep spraying in different parts of the city for two months until I have finished painting all 51 children whose names I had on my list. For me their appearance on the streets of Cairo is a reminder of the conscience of an ongoing revolution, so that we all remember why we went down to the streets and why we are still going down to the streets.

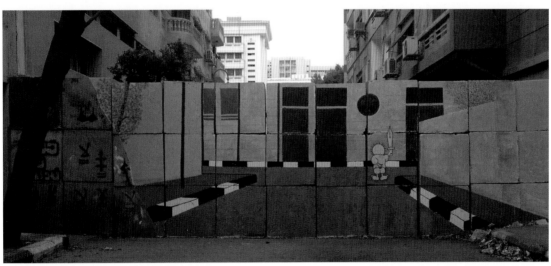

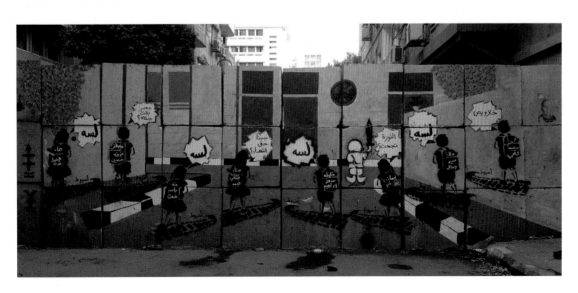

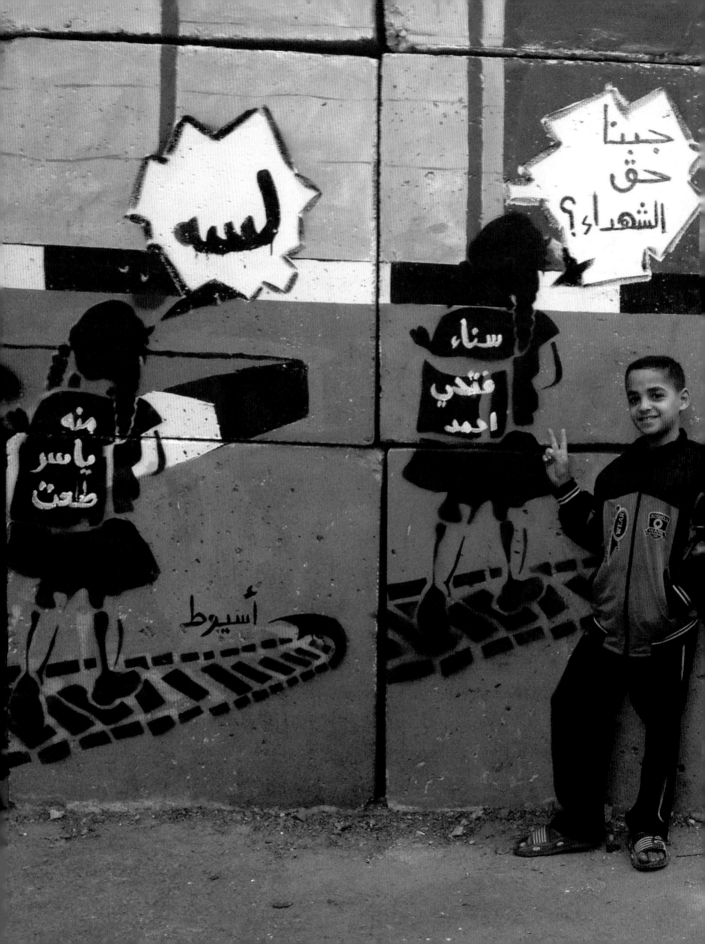

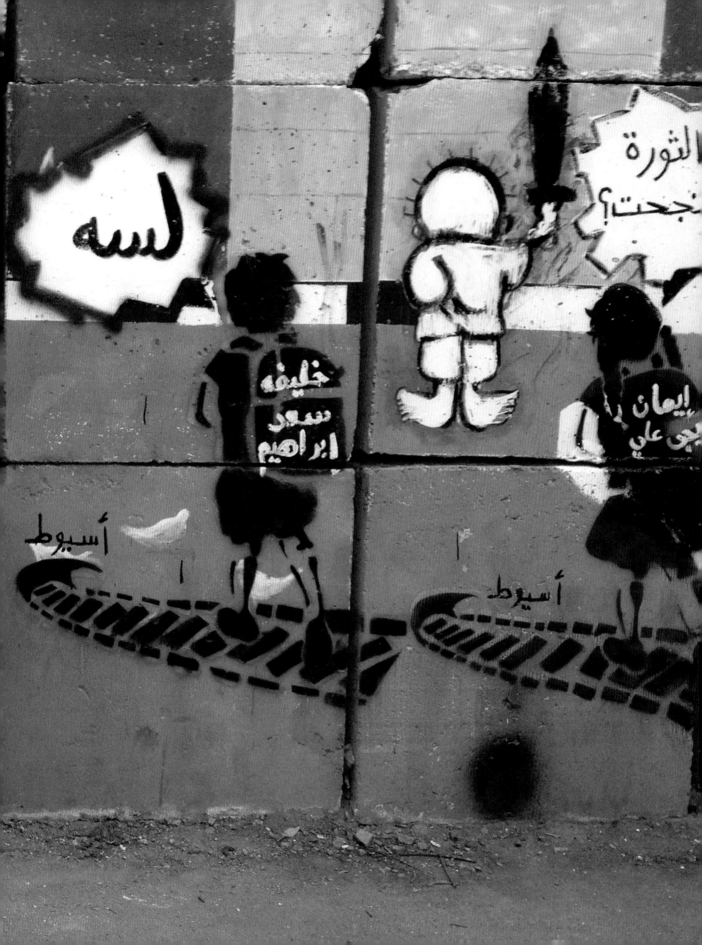

9 Rebel, Cat!

June 2013

Tamarod (Rebellion) is a grassroots movement that, for the past two months, has been collecting signatures from persons who oppose the Muslim Brotherhood regime. It is assumed that two million people have signed the petition so far. They are planning for a mass demonstration on 30 June, the first anniversary of Morsi's inauguration. This time around, I decide to finish my work on the street before the rally starts. I am sure the squares will be full of people and I just want to enjoy being in the square with everyone. So on 7 June I set to work with the aim of feminising the act of rebellion with my art. '*Tamaradi ya outta!*' or 'Rebel, cat!' is my call for more women to join the revolution.

Of course, women have been part of the protests from the beginning. In February 2013, for example, there was a women's march called 'The men of Egypt will not be stripped' after Al-Hayat TV aired live footage of a man being stripped naked and beaten by the police.[9] Women are attending marches armed with sticks, maces and knives, banging pots in front of the Attorney General's office in Cairo. Abdallah posted a cartoon of a man giving a flower to a woman who is saying: 'No, I want a gas mask.'

The response has often been vicious. One radical sheikh has declared that women who join demonstrations are either Christians or widows, and deserve to be raped. There are extremely graphic videos circulating online of women being assaulted on Tahrir Square; many intellectuals and public figures have spoken up to condemn this. There are other videos of women being manhandled in front of the presidential palace, and of violent attacks on women using knifes, targeting their genital areas after raping them.

Yasmin Elbarmawy, a Tahrir rape victim, went on air to express in detail what happened to her. An anti-harassment activist released another video describing the mass sexual assaults in Cairo, which was mentioned in the *New York Times*. In self-defence videos trending on social media, women are explaining the tactics used by rape rings and asking other women to be careful in demonstrations. Meanwhile the psychologist Dr Manal Omar has been creating awareness on TV about the reasons and consequence of mass harassment on the streets.

A meme of famous women is shared on social media with the following caption: 'I am the first female astronaut. I am an international star and UNICEF Ambassador. I run the strongest economy in the world. I represent the foreign ministry of the strongest

Previous page:
74. 'Children of Asyut' playing hide and seek on the trompe-l'œil on the barrier wall in front of the Ministry of the Interior, Fahmy street, downtown Cairo, by Bahia Shehab, January 2013

Top
75. Inverted Egyptian eagles (close-up) on whitewashed Tank Wall, by Alaa Abd El Hamid, 2 June 2013

Middle
76. 'After blood there is no legitimacy', by Mohamed Khaled, Mahmoud Magdy, Mohamed Ismail Shawki and Ali Khaled. Calligraphy by El Zeft, 3 June 2013

Bottom
77. Three female figures on the Tank wall, by Mozza, 2013

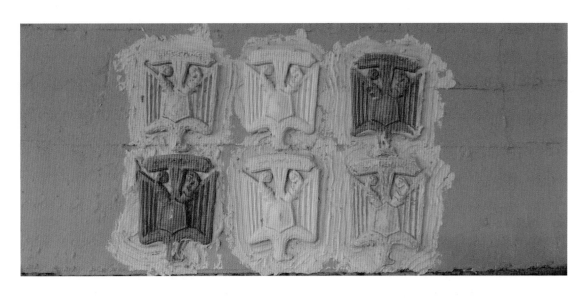

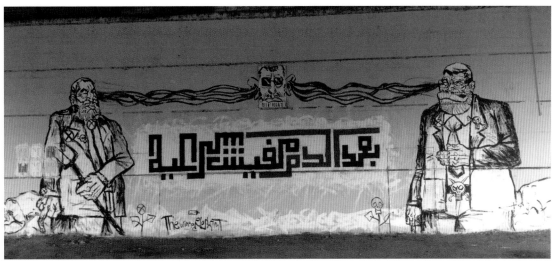

country in the world. I got a Nobel Prize in Chemistry.' And then there is the image of a veiled woman with the caption: 'I'm *'awra* and lacking in mind and faith.'

Biographies of women's rights pioneers from the 1920's and 1930's are circulating on-line. Munira Thabit, for example, was the founder of the magazine *Al-Amal* (Hope) and its French edition *Éspoir*. She was the first Egyptian woman to be licensed as a lawyer by the French law school in Cairo. She was the first woman political writer in Egypt and was critical of the constitution in 1923 because it did not include women's rights.

I would have never heard of Munira if it weren't for a post on social media. Stories like this create links between historical and contemporary activism in our minds. This helps women to understand that they come from a line of fighters, and that other women fought to get them the rights they have today.

Now as the 30 June anniversary of Morsi's election approaches, I decide to direct my next piece of work at women. In the run-up to the anniversary, hired thugs are carrying out aggressive and organised campaigns of sexual harassment to intimidate the women of Egypt from protesting in the squares. They want half the population to keep away. But the women of Egypt are the heart of the revolution. And how better to highlight that than by revisiting the Tank vs Bike wall?

<p style="text-align:center">**</p>

Since my two helpers and I bombed Tank vs Bike in March 2012, many artists have painted and written on the wall, until on 1 June 2013 a group of 'concerned citizens' who live nearby in Zamalek decided to whitewash the whole wall, in the process erasing one of the longest-running street art conversations in Cairo since the start of the rev-olution. Unlike the fans of the military, the Zamalek residents did not just whitewash or paint over parts of the wall to 'retranslate' elements of the original image, but rather removed every trace of the entire set of images. It was as if they were preparing the ground for a new start. And a new start was what they got. Artists reacted immediate-ly. On 2 June, Alaa Abd El Hamid added six eagles from the Egyptian flag to the wall, moulded in stucco. El Hamid placed the eagles upside-down in the area formerly occu-pied by the tank and painted them in bright fluorescent colours: two pink, two yellow and two green. Desecrating the flag by hanging it upside down can be interpreted as a declaration against government policies.

On 3 June, a new, large mural appeared on the wall, depicting three senior figures from the Muslim Brotherhood: Mohammed Badie, the Supreme Guide (or Murshid) of the Brotherhood at the time; Khairat el-Shater, the Deputy Supreme Guide; and Morsi himself. The three figures are over two metres in height and are painted in a very car-toonish manner, using strong black lines on a lightly whitewashed background. On the

Opposite:
Top
78. Belly dancer by Mozza, damaged by anonymous, 2013

Middle
79. 'Rebel, cat!', by Bahia Shehab, 5am, 7 June 2013

Bottom
80. Full view of the 'After blood' mural with 'Rebel, cat!' stencils, by Bahia Shehab, 2013

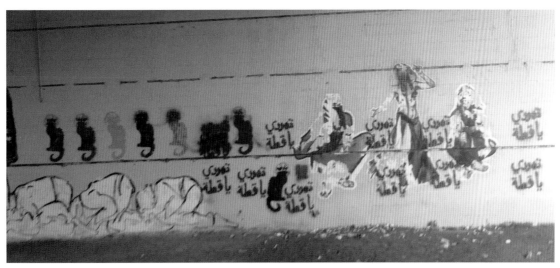

left side of the image, el-Shater stands holding a devil's trident in his left hand. His right arm hangs by his side with the middle finger sticking out, in a gesture signifying arrogance and indifference to his critics. On the opposite side of the image is Morsi, with his right hand making the same offensive gesture. In the centre floats the disembodied head of Mohammed Badie, the Supreme Guide. Wavy black lines stream out of Badie's ears and into the ears of el-Shater and Morsi on either side of him, as if his ideas are flowing directly into their brains. In between el-Shater and Morsi and under Badie's head is a large slogan in rectilinear Kufic script declaring that 'After blood there is no legitimacy'. The word 'blood' is painted in red while the rest of the calligraphy is in black. On either side of el-Shater and Morsi, figures kneel in a prayer position, as if worshipping the Brotherhood leaders. The artwork is by Mohamed Khaled, Mahmoud Magdy, Mohamed Ismail Shawki and Ali Khaled, and the calligraphy is by the artist El Zeft.[10]

On 4 June 2013, an artist who goes by the name Mozza[11] pastes[12] three female figures onto the wall, next to the 'After blood' mural: two crouching and veiled women flanking a standing belly dancer. The faces of the veiled women are covered; the belly dancer reveals a long, bare thigh but her face has no features, and hence she is also faceless. The image is a brilliant provocation, juxtaposing religious modesty with a distinctly Arab form of sensual display. The three women, covered and uncovered, are a witty rejoinder to the three leaders of the Muslim Brotherhood and an assertion of the diversity of Egyptian women, perhaps even a suggestion that behind every veil is at least the possibility of a belly dancer? Here is graffiti representing another important aspect of social and political life — namely, the position and status of women in different walks of life.

<p style="text-align:center">**</p>

I am out of town when the locals from Zamalek whitewash the wall, otherwise I too would have gone to paint on 2 June. Instead I follow the progress of the wall online and plan my own retaliation.

When I arrive at the wall at 5am on 7 June 2013, the belly dancer has already been slightly damaged. Without having seen Mozza's work, I too want to address women this time around. The aggressive, organised and targeted sexual harassment campaigns that were used to intimidate Egyptian females and dissuade them from joining the protests on the streets demand a response.[13]

Intended to feminise the act of rebellion, my 'Rebel, cat!' campaign is a call to women to join the revolution. I create a stencil of one of my favourite images, the cat from Théophile Steinlen's iconic 'The Black Cat' cabaret poster, and write next to it the slogan 'Rebel, cat!'. I use the feminine form of the verb 'rebel' to ensure women understand that the campaign is addressing them, and 'cat' because it is a common term men call out to sexually harass women on the street.

My friends M. and N., two young women who wanted to help me spray, come with me.

Opposite:
81. Damaged belly dancer + red 'Rebel, cat!', by Bahia Shehab, 7 June 2013

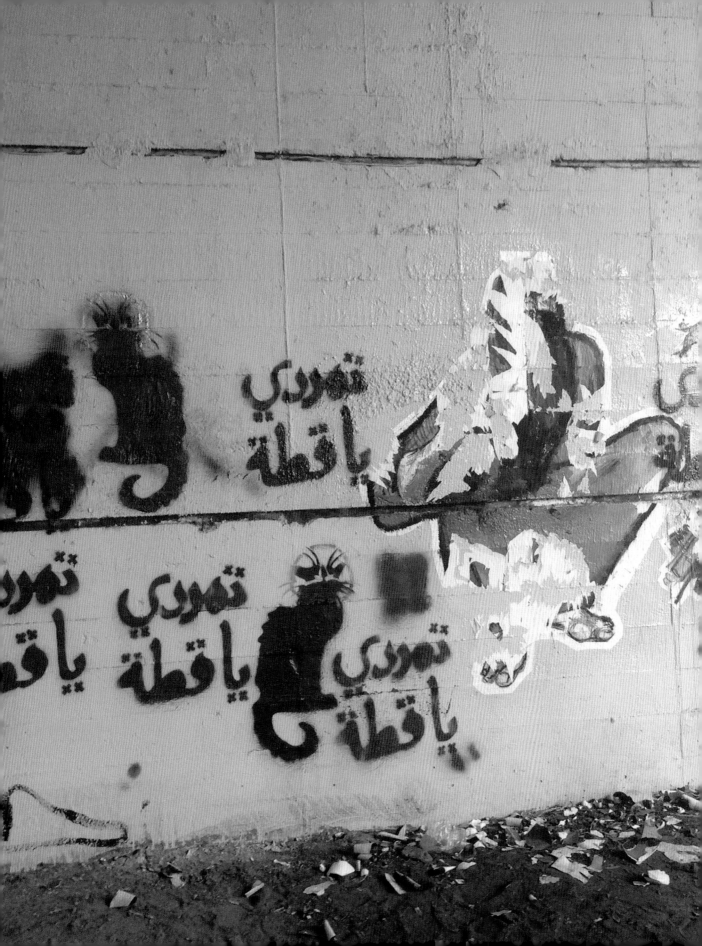

As soon as we take out our stencils, we are attacked by three men. I am not sure what is bothering them — whether it is the message we are spraying or the German ZDF TV crew who are covering our work[14] — but they quickly become very aggressive. This is the fastest I have had my work covered over: five minutes into our work one of the men is spraying over my message using one of my own red spray cans. They also start to aggressively peel off Mozza's images of the three women. We get into the car and drive off. When we return thirty minutes later, the men have gone and we continue working on the wall. In the end we spray seven cats, each in a different colour and with a golden halo around their heads. We also spray the slogan 'Rebel, cat!' ten times over Mozza's damaged work, where the vandals have sprayed red onto the belly dancer's faceless face.

We move on to a wall on the other side of Zamalek and I spray another message, directed to the men who want to silence and intimidate the women of Egypt; men who want to claim that a woman's hair, body and face, even a woman's voice itself, is part of her *'awra*, shameful or intimate parts that must be kept covered according to some interpretations of Islam. I spray a large red outline of a head with a brain composed of naked female body parts. Alongside it is the message *'Mokhak 'awra'* — 'It is your brain that is shameful and should be covered'. While I am working, a police car stops and asks for my ID. I refuse to hand it to them, so they decide to detain the film crew who are documenting our work. I tell the policemen that I am painting this for their mothers and sisters who are in danger of getting raped on the streets, and they decide to let me and my two friends go. It's the camera and the possibility of being exposed by someone telling a story that threatens them, it seems, not a few women painting cats on a wall. To them we are harmless.

Quickly we climb into my car, but not before the cameraman has slipped his memory stick into my pocket. The crew get into the police car and the car drives away. They are released a few hours later. The naked women looking like a brain are pasted onto the wall, not sprayed. I know that passers-by will tear them away, the way they are tearing down our right as women to belong on the street without being constantly harassed. Sure enough, when I return the following day, the brain in my stencil stands empty. It's a clearer message: the brains of those who attack us are *'awra* — and they are empty after the women are removed.

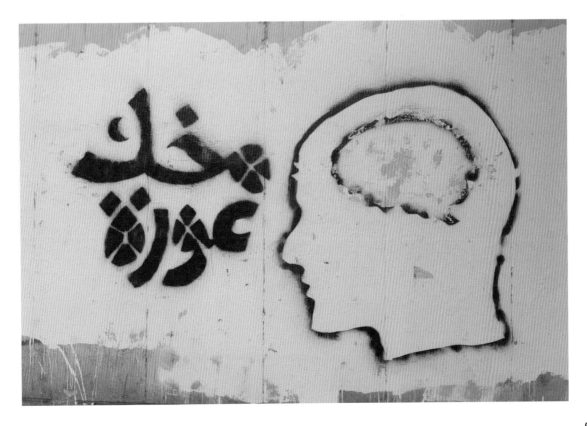

10 Stealing the Dream

June 2013

In the build-up to the 30 June demonstrations, the Tamarod movement goes from strength to strength. Omar Samra, the first Egyptian to climb mount Everest, posts a photo of himself from the top of a mountain in Alaska carrying a flag with the hashtag #tamarad. Tamarod claims to have collected ten million signatures so far.

Reminders are circulating that the protest should be peaceful, with no raising of political party flags, no surrounding the Ministry of the Interior, no attacks on public or private property, no attacks on prisons, no attacks on the police. People are supplying each other with support resources before the demonstration: emergency numbers in Cairo, Alexandria and Mansoura for help with medical and psychological needs, for children who have been attacked and those who have been tortured and harassed.

Led by Amr Moussa, Mohamed ElBaradei and Hamdeen Sabahi, Jabhat al-Inqaz (The Salvation Front) has suggested two scenarios for the aftermath of the 30 June demonstrations. The first is to install a presidential council of five, comprising the head of the Supreme Court, one person from the military leadership, and one from each of the three political parties, liberal, left and Islamic, to form a technocratic government that will run the country for six months until new presidential elections take place. The second scenario is that the Supreme Court will manage the country for six months and it will form a technocratic government headed by a skilled prime minister, to prevent any issues surfacing from the choice of the presidential council, and then a presidential election will take place. Activists are making it clear that from 30 June onwards 'The army protects. It doesn't rule'.

<p style="text-align:center">**</p>

On 30 June we go down to demonstrate for an end to Muslim Brotherhood rule, one year after they took power. Government and state media claim that 33 million people protested on 30 June and on 1 July all over Egypt, a number that seems to be quite inflated. I do not trust any statistics issued by a governmental entity.

Women have brought their children to the squares. After witnessing this, I think that we can't possibly lose. The most beautiful scene in Tahrir this time is the women's zone, which is surrounded by men to protect them from any kind of harassment. The most

beautiful chants come ringing from this section, from the voices of these women who know that they are the core of the revolution. On the day, I take my own daughters. I've agreed to meet some friends in the square, but we can't even make it into the square because of the crowd. We stand on the Qasr el-Nil bridge and the girls wave their flags, then we go back home. Honestly, with the military jets flying overhead, it felt more like a military parade than a revolution. My husband refuses to go with us this time. My Iranian friends call me to tell me this is a military coup, but I do not believe what they are saying. This is a revolution. We are continuing what we started. I won't let anyone steal this beautiful dream.

State TV shows millions of people on the streets in different cities all over Egypt. There are eleven tanks lined up in front of the Ministry of Defence. Long flags hang from buildings along with banners some 20-storeys high commanding: 'Leave!' There are large green laser projections on the façade of Mogamaa al-Tahrir. It's a full-blown laser show and feels like a long pre-planned carnival.

In cyberspace people are trying to remind us of all the crimes committed by the military.

Muslim Brotherhood headquarters are being destroyed. People are being asked to remain on the streets until all the heads of the Muslim Brotherhood are detained. On television, we see that there are mass demonstrations in Mahalla, Sharqiyya, Sidi Gaber, Tahor, Ittihadiyya, Alexandria, Damietta, Kafr El Sheikh, Tanta. Various local and international sources have different names for what is happening, from a military coup, to 'correcting the revolutionary course'.

On 3 July 2013, Mohamed ElBaradei appears on TV along with national religious figures and General Abdel Fattah el-Sisi, and several other army generals, to announce the ouster of Mohamed Morsi from his post as president and declare a new roadmap for Egypt. Pro-Morsi supporters flood the streets in their thousands, occupying two major squares, al-Nahda and Rabaa al-Adawiya. Those of us who came out to protest on 30 June refuse to believe this is a military coup, because it is also the will of the people. We went in our millions to demonstrate against the Brotherhood regime. A video circu-lates of General el-Sisi declaring that he only wants to see Egypt become the best coun-

try in the world, that the army has no desire to run the country and is only concerned with realising the will of the people. And we the people, like ignorant gullible lambs, believe him.

Rabaa al-Adawiya Square is full of Morsi supporters. Muslim Brotherhood demonstrators are pouring onto the streets everywhere. The revolutionary factions are gloating, reminding the Brotherhood that, while the Brotherhood's relationship with the military has changed only now, the revolutionary factions have been chanting 'Down with the military!' since 25 January 2011. The webpage 'Documenting the Egyptian Revolution' shares a video recording of cases of mass arrest, torture and murder, under the command of the current Minister of the Interior, Mohammed Ibrahim (who has remained in his post since the ousting of Morsi). The killing of Brotherhood and non-Brotherhood protestors continues on the streets. There are heated debates over the number of demonstrators in Rabaa; analyses of aerial views of the square suggest there can be no more than ten to fifteen thousand people, based on the number of tents. The government floods Rabaa with sewage in an attempt to drive people out. But the Brotherhood demonstrators keep filling the square. The dismantling of the Brotherhood is the headline in every local newspaper. *Sawt al-Umma* has an image of the Muslim Brotherhood leadership next to Trotsky's slogan: 'Into the dustbin of history.' The issue includes a poster of el-Sisi in his military uniform.

On 14 August 2013, the Egyptian army and security forces raid two Muslim Brotherhood protester camps in Cairo. Initiatives to end the six-week sit-ins by peaceful means have failed. The camps are cleared out within hours. Human Rights Watch will later describe the raids as 'one of the world's largest killings of demonstrators in a single day in recent history'.[15] Reports coming from Rabaa Square are hellish. Pictures are circulating from the hospital near the square showing rows of bloodied bodies with their hands and legs tied. Journalists who have been to the site — some have been war reporters — tell me they have never seen so many corpses in their lives. Human Rights Watch will later report that a minimum of 817 people died on Rabaa Square alone. The Egyptian Health Ministry will report that 638 people were killed and at least 3,994 injured. The hospital next to Rabaa has rooms filled with hundreds of corpses. We did not sign up for this.

Now the witch-hunt is on. Every broadcaster on every station uses the word 'criminal' before the word 'Brotherhood', as if they are all reading from the same paper in different voices. There is now one voice, the voice of death, and we are its accomplices. I cannot describe the guilt and shame I feel. The military have turned us all into criminals. They moved into Rabaa with the people's blessing and then killed hundreds. Ten days after the massacre a video emerges on YouTube of a bulldozer pushing and driving over bodies, piling them up for burning. The nearby mosques and hospitals are full to capacity, and they are not even being given time to remove the dead.

A deafening quiet follows. As the families of the martyred in Rabaa — those who can — collect the corpses of their parents and their children, the country has been silenced

by a crime we have collectively been tricked into endorsing. The situation with Rabaa needed gentle handling to ensure a bright future in a healed country; instead, the military used an iron first. Now we are all responsible for sanctioning criminals as they commit their crimes.

**

Adly Mansour is appointed transitional president. Two weeks after the massacre the government appoints a 'committee of fifty' to write a new constitution. The committee includes six religious figures — three Muslims and three Copts — as well as four representatives of young people — two from the Tamarod and two from the 30 June Front — alongside a collection of known public figures and heads of unions. Only five members out of the fifty are women. One ex-Brotherhood member and no real members of street opposition are at the table. The cake has been divided in such a manner to keep the public entertained, but the real stakeholders in this debate are not represented. The fox has taken over the hen coop.

Ahmed Maher, leader of the April 6 Youth Movement, is in jail. The voices that have been calling for equality and freedom will soon be systematically silenced and only one voice will rise. On the forty-third anniversary of the death of President Nasser, General Abdel Fattah el-Sisi poses for a picture with Nasser's family. The image is already being crafted. The vote on the new constitution is set for 14 and 15 January 2014.

A street seller is selling both Morsi and el-Sisi stickers. He is just trying to make a living, no matter whose side you are on.

SAMSUNG

Samsung
GALAXY S III

SAMSUNG

El Saf

11

A Conversation

July to October 2013

In April 2013, I sprayed some of my Children of Asyut on a wall near a Cairo ring road. I left the speech bubbles empty in the hope that passers-by would fill them with their own dreams. But nothing happened. I would drive by the wall and nobody had written anything. One night, a few weeks later, I just went ahead and filled them in myself, using the same questions I had used on the barrier wall outside the Ministry of the Interior, such as 'Did education improve?' or 'Has Egypt become heaven on earth?'. To each question the next child answers 'Not yet', reminding us that the hopes of the revolution have not yet been fulfilled.

Now, after the events of 30 June, my images of the Children of Asyut have suddenly come to life. People are modifying and adding lines. A conversation has begun. The children are talking.

Every wall we spray becomes a conversation, an open invitation for people to look or comment or ignore. Everything we paint becomes an idea with a life of its own. Passers-by have the right to add to it, subtract from it, or erase it altogether. On the streets our work is alive. People pass it every day on their way to work or to buy groceries.

By posting our work online we give our work a new form of life and a new meaning. We share our messages not just with the inhabitants of Cairo or Egypt: we send our messages to the whole world. We keep telling the story of the revolution on the streets in the hope that we can change our future and the future of a whole nation. That the work is covered over is insignificant. What matters is keeping the conversation going.

Previous and current pages:
85. 'Children of Asyut',
painted on ring road,
Cairo, April–August 2013

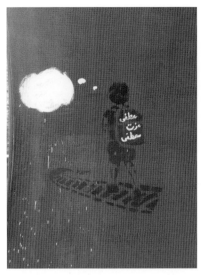

86. 'Children of Asyut' painted on ring road, Cairo, April–August 2013.
Inside bubble (in black by artist): Has the revolution succeeded?
Line 1. Sprayed in red: Morsi is my president
Line 2. Sprayed in red: Islamic not secular

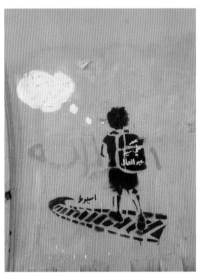

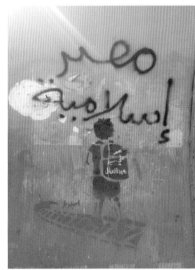

87. 'Children of Asyut' painted on ring road, Cairo, April–August 2013.
Inside bubble (in black by artist): Not yet (covered in white)
Line 1. Sprayed in red: CC is a traitor and a murderer
Line 2. Sprayed in green: Remember Allah

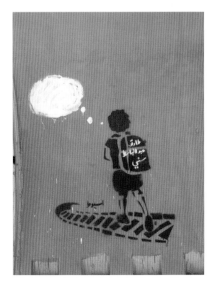

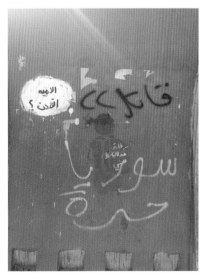

88. 'Children of Asyut' painted on ring road, Cairo, April–August 2013.
Inside bubble (in black by artist): Has illiteracy disappeared?
Line 1. Sprayed in black: CC is a murderer
Line 2. Sprayed in white: Syria is free

89. 'Children of Asyut' painted on ring road, Cairo, April–August 2013. Inside bubble (in black by artist): Khalawees? (Ready?) Line 1. Sprayed in black: Do you know that Morsi is your president Morsi is your president Morsi is your president

90. 'Children of Asyut' painted on ring road, Cairo, April–August 2013. Inside bubble (in black by artist): Has education improved? Line 1. Sprayed in green: Remember Allah

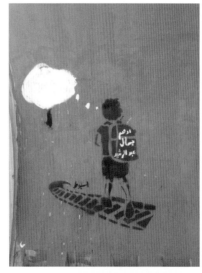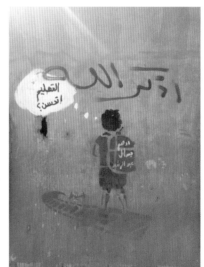

91. 'Children of Asyut' painted on ring road, Cairo, April–August 2013. Inside bubble (in black by artist): Has Egypt become heaven on earth? Line 1. Sprayed and scratched in paint: They [meaning the Muslim Brotherhood] are the terrorists Line 2. Sprayed in white: Egypt is free

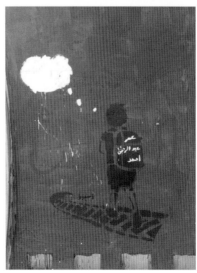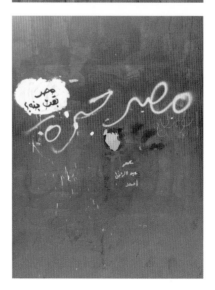

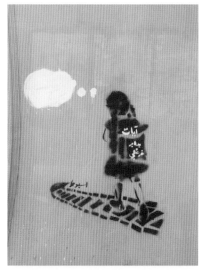
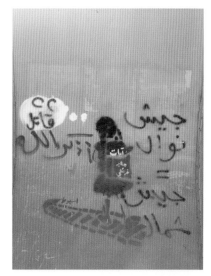

92. 'Children of Asyut' painted on ring road, Cairo, April–August 2013. Inside bubble (in black by artist): Not yet? (in red): CC is a murderer[16]
Line 1. Sprayed in red: Nawal's army[17]
Line 2. Sprayed in red: Left army[18]

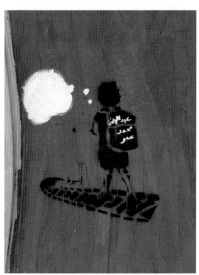

93. 'Children of Asyut' painted on ring road, Cairo, April–August 2013. Inside bubble (in red): Congratulations on the new paint
Line 1. Scratched in the paint: Fuck the Muslim Brotherhood
Line 2. Scratched in the paint: They [meaning the Muslim Brotherhood] are the terrorists

94. 'Children of Asyut' painted on ring road, Cairo, April–August 2013. Inside bubble (in black by artist): Not yet? (in red): CC is a traitor
Line 1. Sprayed in black: We are going to defeat defeat

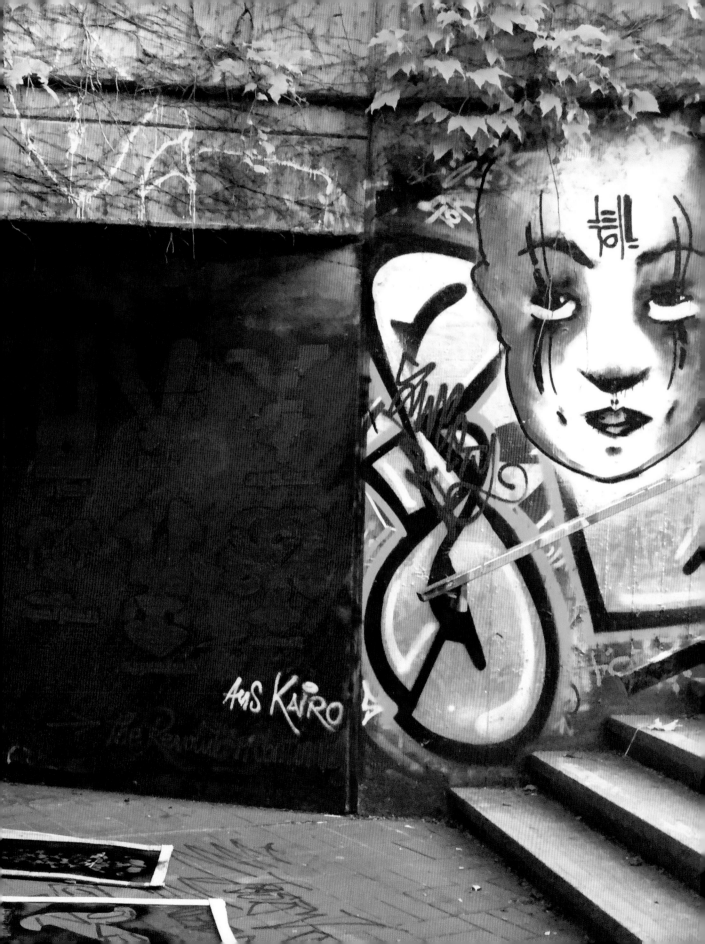

12 Ten Years On: May You See Days Better than Mine

I was among the many Egyptians who protested against Muslim Brotherhood rule on 30 June 2013. Mohamed ElBaradei, Nobel laureate, diplomat and trusted political figure during the revolution, appeared alongside national religious figures and army generals (among them our future president, el-Sisi) to announce the ousting of Mohamed Morsi and to declare a new way forward for Egypt. We trusted that we would have fair elections and that the military would not take over the country again. We refused to believe this was a military coup, because it was also the will of the people: we had turned out in our millions to demonstrate against the Brotherhood regime.

In March 2014, General Abdel Fattah el-Sisi resigned from his post as head of Egypt's armed forces to announce that he would be running for presidency. He had had his medical checks and been declared fit. The only serious candidate against el-Sisi was Hamdeen Sabahi and we knew he didn't stand a chance. My tail telephoned me to ask me who I was going to vote for. I told him I was reading up on both candidates and would make a decision when it was time to vote.

Two months later el-Sisi was elected president by winning 97% of the votes. Or so we were told. The new constitution gave — and still gives — the president unprecedented powers. Protestors need permission to demonstrate. Civilians are subject to military trial and may be imprisoned for an unlimited time without the benefit of a civil trial.

After the summer of 2013, all signs of the revolution were erased from the streets of Cairo. The crackdown on activists has been escalating ever since. Any sign of opposition is immediately crushed. From 2015, we started celebrating Police Day on 25 January, and the revolution that began on that day has not been mentioned in mainstream media ever since.

The country is still divided as to whether what happened in 2013 was actually a military coup masquerading as a mass protest. History is never understood in the moment; it may only be many years later that all the stories finally come to light. I am still trying to understand how we, the people of Egypt, created a window of freedom on the streets between 2011 and 2013 — and how it was shut so brutally. I am still trying to understand the protests that took place on 30 June 2013 and my role in them. Like many Egyptians, I am still trying to make sense of our revolution and to see a hopeful pathway into the

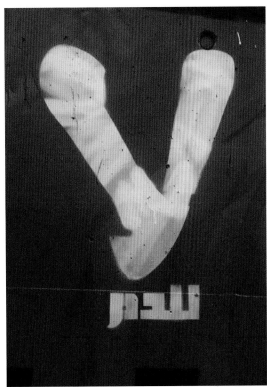

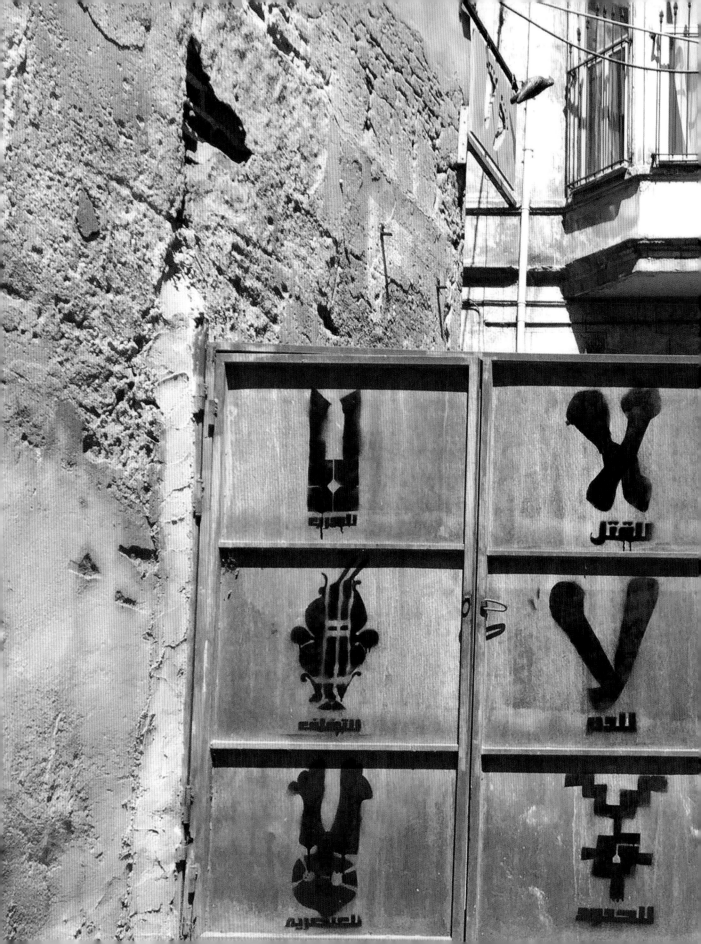

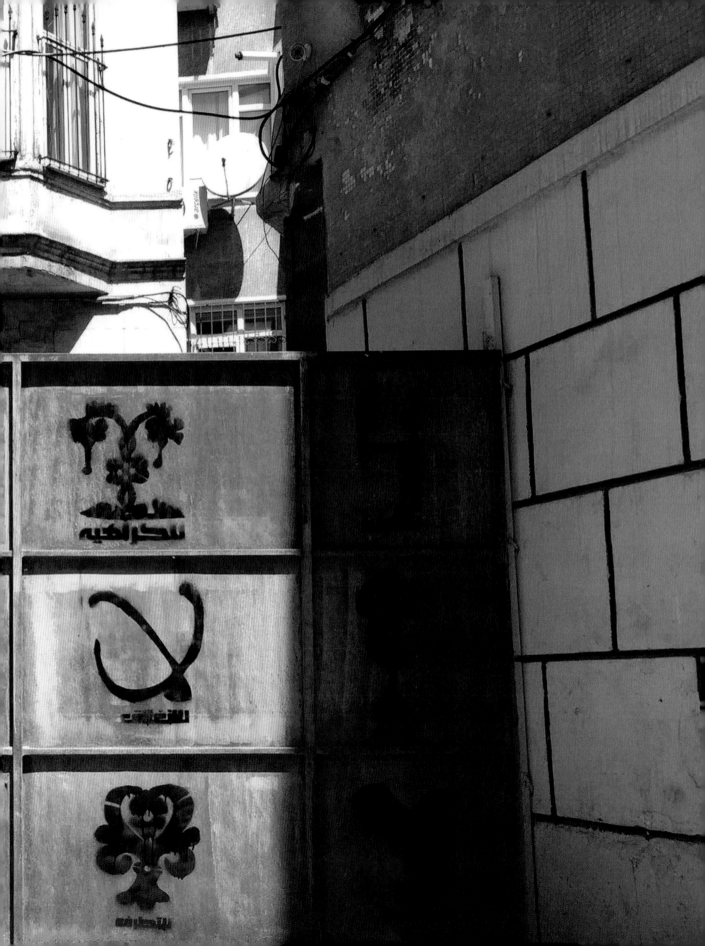

future. How did we become revolutionaries? How did we become accomplices of the counter-revolution? And what may we yet become?

**

People took to the streets, at least in part, thanks to social media networks and the access these provided to information. Like-minded people had a tool to find each other. The revolution of 2011 was driven by, and contributed to, a transformation in the quality and quantity of news we were consuming online in Egypt. When I analyse and decode my newsfeed, I can understand better why people went down to the streets.

For many people who, like me, did not take part in the first wave of the revolution, seeing images of the dead and injured on the streets persuaded them to take the risk of participating in the revolution in one form or another. The concept of the martyr as hero is familiar to Arab societies. In the virtual world of social networks, people reinvented a concept already present in Islam. Images of young women and men carrying their white funeral shrouds in demonstrations circulated, sending a clear message that young people were not afraid to die. Most were willing to give up their lives, not for their religious beliefs, but for the hope that their children would have a better future.

The visual newsworthiness of the protests led to the idea of a *révolution en vogue*. Wearing an eye patch became a kind of status symbol, because social media and mainstream media alike celebrated people like Ahmed Harara, a dentist who went to demonstrate on 28 January 2011 and lost his right eye to a sniper shot. (In November 2011, he lost his left eye to another regime sniper.) Egyptians and their media celebrated the sacrifices of the injured and — yet more powerfully — made the martyrs into ultimate role models.

Each segment of Egyptian society lost someone who became a symbol for one reason or another. The death of Khaled Said, a young man killed by the police in Alexandria, was one of the sparks that lit the 2011 Egyptian revolution. Mina Daniel became a martyr for the Copts, Sheikh Imad Effat for Al-Azhar University and Muslims in general, and al-Hosseini Abu Deif for journalists. The 74 football fans slaughtered in Port Said became symbols for the Ultras, and sixteen-year-old Gaber Salah ('Jika') became a martyr for the April 6 Youth Movement. Those who came into the public eye did so either because of their youth or because they had friends and family who shared their stories online. Portraits and names of many of those killed were painted on the walls of the city or on banners that were carried during demonstrations.

Humour too helped break the barrier of fear. The ruling regime (of Mubarak or SCAF or Morsi) was heavily mocked in memes, videos and jokes circulated online. In one famous image two young men diving in scuba gear carry a sign addressed to the then President Hosni Mubarak that reads: 'Leave before we run out of air.' Later another scuba diving activist held up a sign that made clear that even the fish in the sea rejected

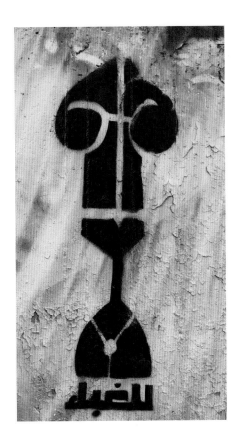

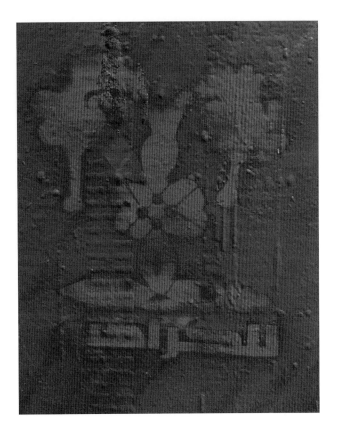

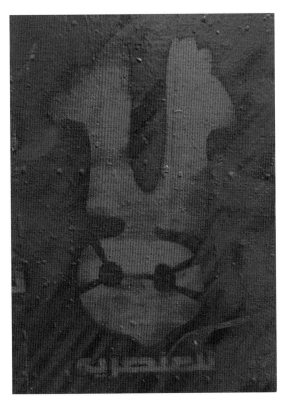

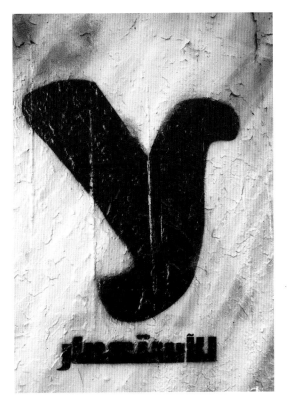

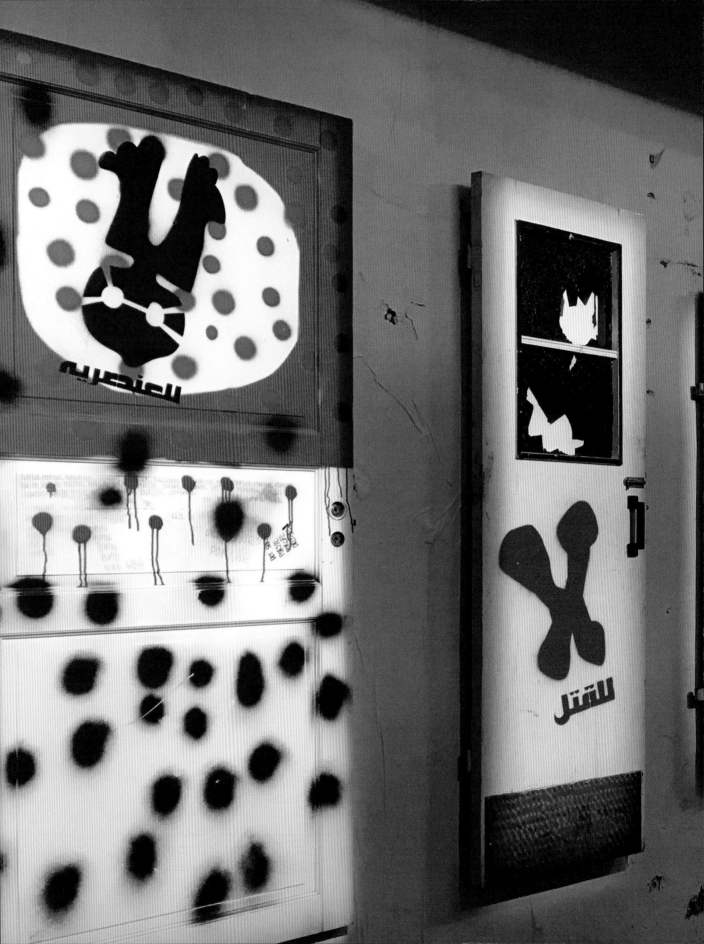

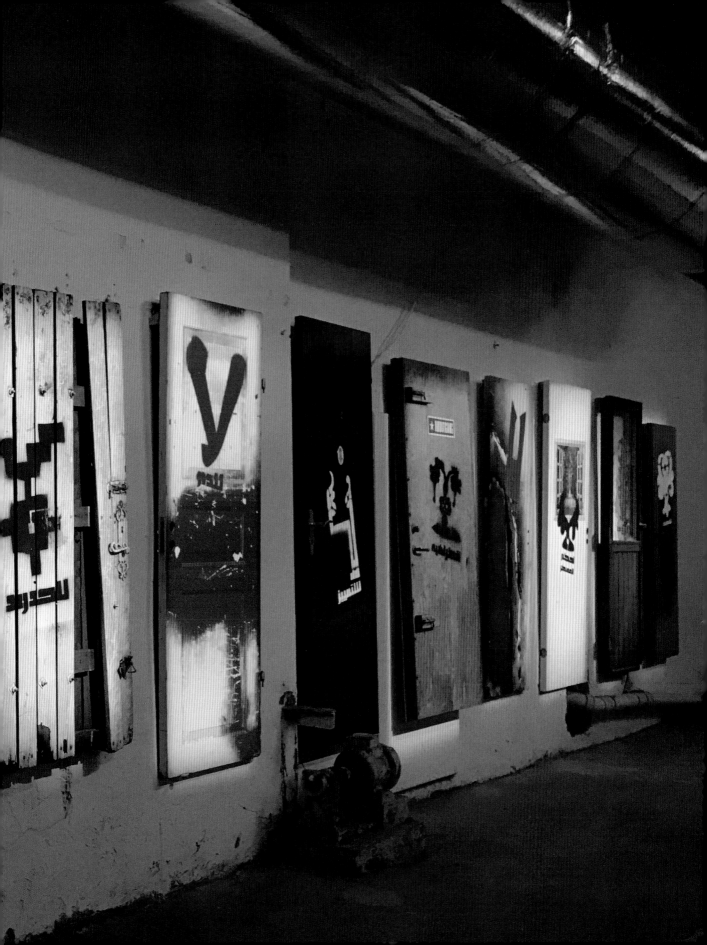

the new constitution of Mohamed Morsi. Social media can be a tool for communicating fearlessness.

Satire thrived throughout the revolution. Its most prominent exponent was Bassem Youssef, a YouTube sensation who became a star TV presenter in the course of a year. He moved from being popular with those who had internet connection, and therefore knew the most about the revolution, to being a hit among the millions who only had access to television. This would have been unimaginable under Mubarak. Youssef was a prominent contemporary addition to the long tradition of Egyptian satirists who have become famous in the Arab world.

Another key element in breaking the barrier of fear was the citizen reporter. Technology has put video and photographic cameras in the hands of billions. Citizen reporters are faceless and nameless and they are everywhere; they could be anyone, from the porter to a guard inside a secret meeting room to a young woman on the street. The people have discovered the power of the documentary image. When the Egyptian government declared that they were not shooting live ammunition at protestors, images circulating online quickly proved otherwise.

Alongside these citizen reporters came the 'rebel professionals', those who contributed their expertise to the revolution free of charge. Doctors went down to the streets to help the wounded, lawyers helped the detained, musicians composed music that inspired and drove the masses onto the street, actors performed plays in the square telling stories about the revolution — and artists, like me, painted messages that highlighted the atrocities of the regime and called for action.

Some of the most important teachers in post-revolution Egyptian online society have been the archivists and historians who dig up lessons from the past, especially from old newspapers, and share them at key moments. Online, we are learning things we never learned in our school history books. We are also learning from people in other nations. From Japan, Turkey, Indonesia, Iran, Spain, Saudi Arabia and New Zealand, people are sharing lessons and case studies, the good and the bad, in leadership, economics, politics, and the environment.

Data is circulated through memes that are easy to comprehend. Anyone with basic software skills can play a vital role, by simplifying information into sharable memes. But professional designers also contribute when needed, especially by creating infographics that help to get complex ideas across.

The street and the online world are constantly in dialogue. Something happens on the street, someone documents it and posts it online, it finds an audience, and the post is shared extensively. Later, perhaps, someone in the media picks it up and airs it, it goes viral, and yet more people start talking about it or reacting to it by heading out onto the streets to demonstrate.

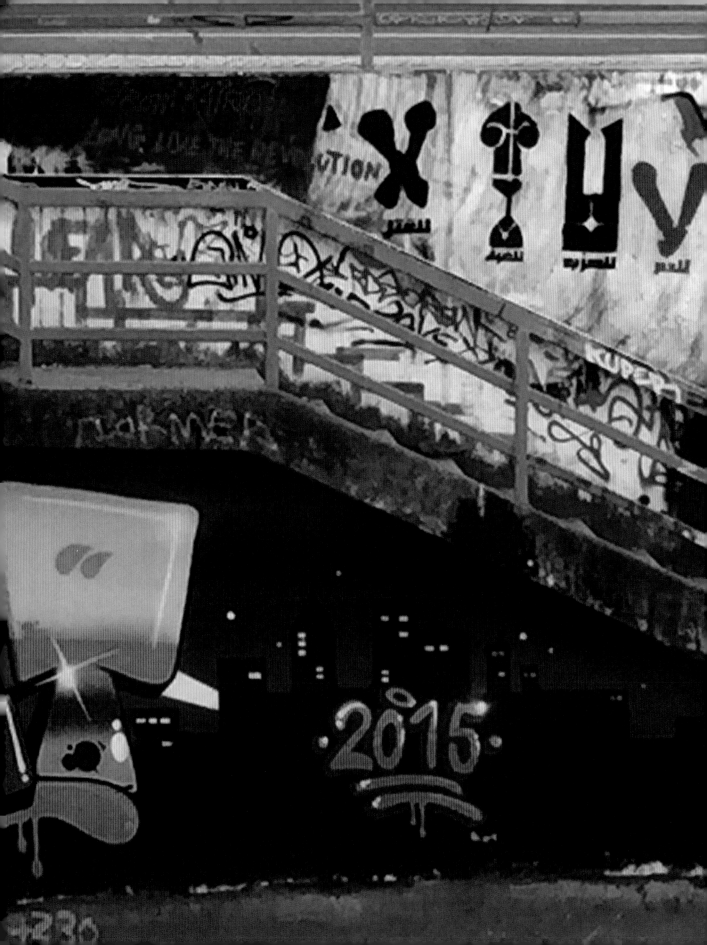

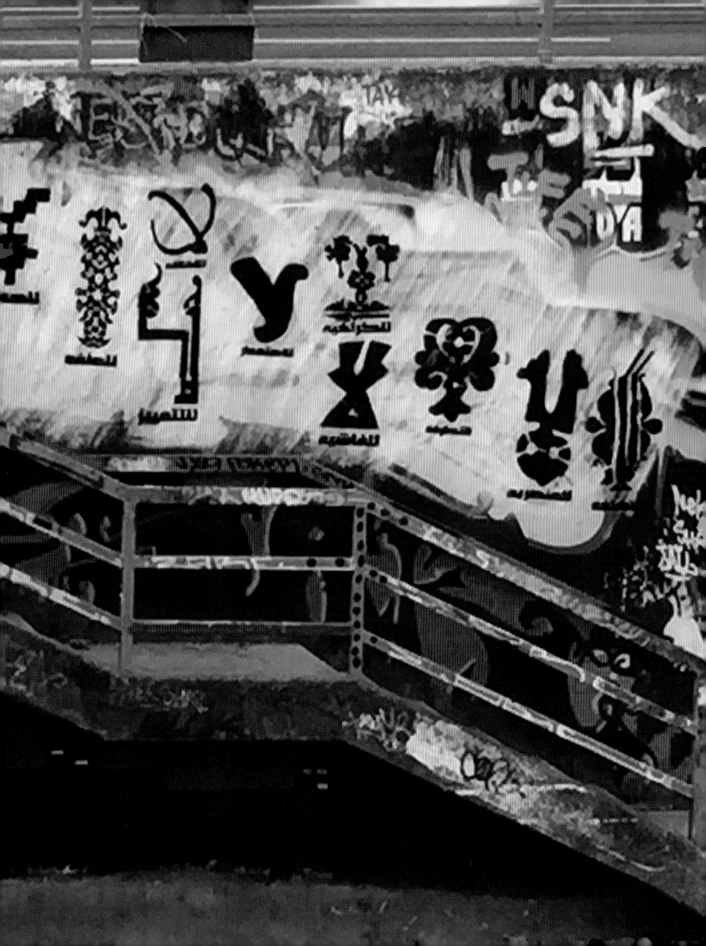

Often it begins with individuals sharing information with the world. But there are also key players online who assume a major role in influencing people, such as the now-inactive Facebook page 'We are all Khaled Said'. At its height, this Facebook page had more than three million followers. One of the major contributions it made to the second wave of the revolution was to dig up old video interviews with politicians and public figures and share them online at pivotal moments. Contrasting old statements with the new helped expose the politicians' hypocrisy. The internet never forgets.

During the Egyptian revolution, art sublimated violence and transformed high emotions into powerful messages. Music, theatre, video art, graffiti and cartoons were just some forms of the media of protest that flooded the streets and cyberspace. Strong emotions drove intense creativity and in the process artists and laypeople alike provided us with exceptional examples of how to express dissidence and solidarity without violence.

The revolution gave rise to social initiatives led by young people communicating their needs and dreams and educating others. A group called Qabila started posting a series of simple animations on YouTube, illuminating the democratic process, explaining in simple terms over several episodes what a constitution is, what a parliament is and so on. In the beginning of the revolution, people shared information about demonstrations: times, routes, emergency numbers and security tips.

Another reason Egyptians revolted against Morsi, as they had already against Mubarak, is that their view of the role of a president had changed. To many Egyptians, the president is no longer the father who must be feared and respected, as in the time of Mubarak, but rather a civil servant. After the first wave of the revolution, the people realised that they deserved better service from their government. This political awareness made Egyptians follow the words, promises and actions of their president closely. If he gave a speech full of mistakes, a historian corrected him and published the corrections online for everyone to see. If the president's wife shut down a street in a part of the city to secure access to a religious class, the residents of the area voiced their discontent. The president and his entourage were under constant scrutiny from everyone with internet connection. And the mainstream media picked up and magnified his actions.

It is true too that the Muslim Brotherhood, with Morsi as a figurehead president, had a golden opportunity to bring together all the factions of the revolution. This it chose not to do.

People in the mainstream media and elsewhere were aided by those hostile to the Brotherhood within the governing institutions — who, for example, constantly leaked confidential information to embarrass the regime. All Morsi's mistakes were amplified by Mubarak's deep state, which was largely still in place, and collided with the hopes of a nation that had just emerged from a revolution desperate to reform a country that had been suffering from political corruption for over four decades.

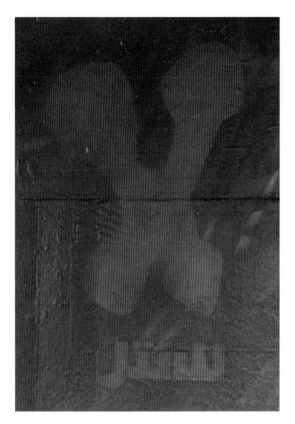

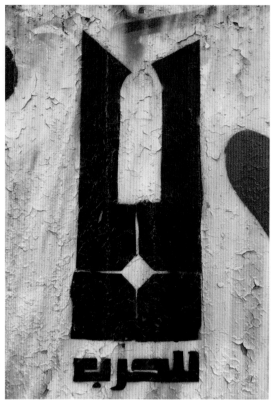

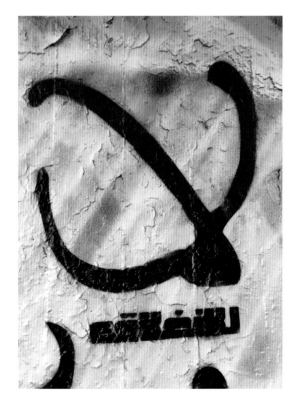

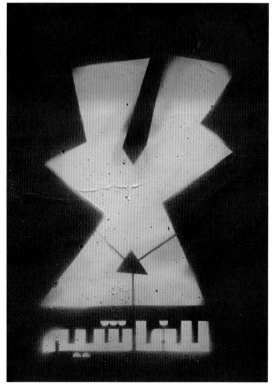

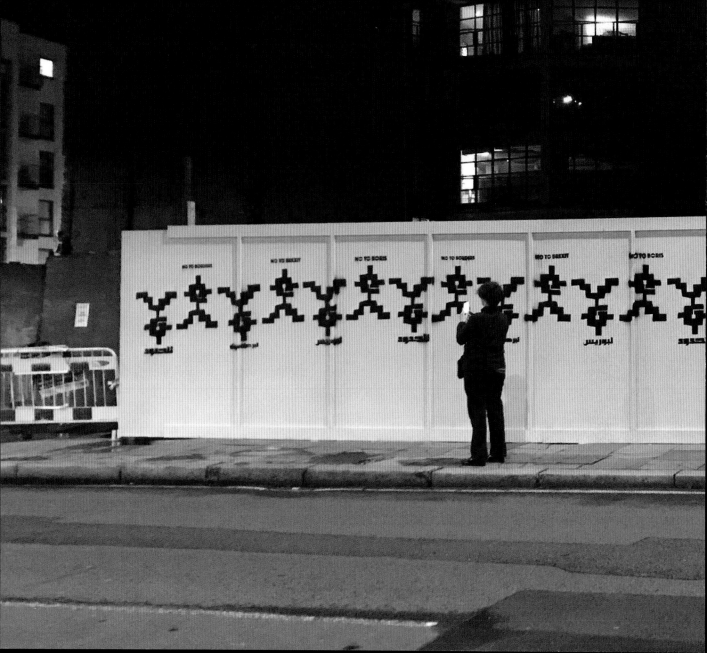

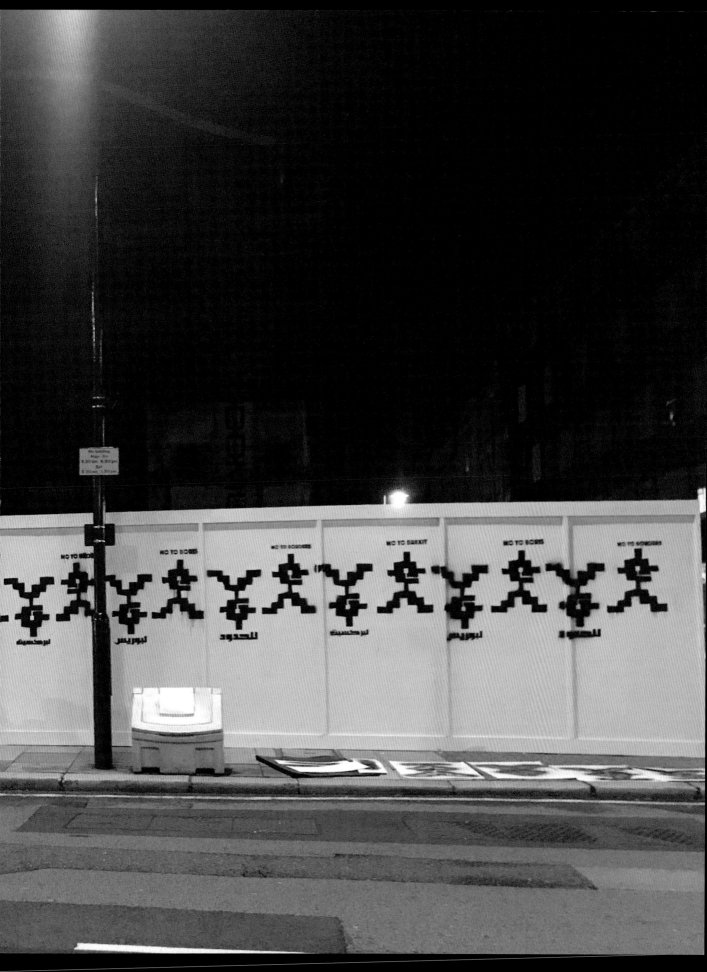

In the end, many of the same factors that enabled the uprising of 2011, and which opened up the precious window of freedom for Egyptians to express their frustrations and longings, also contributed to the downfall of Morsi. Activists used the same techniques that succeeded in ousting President Mubarak in the first wave to oust the Muslim Brotherhood in the second wave. In a 2011 image, a military tank is sprayed with graffiti that reads 'Down with Mubarak'; a similar image of a tank in late 2012 bears the message 'Down with Morsi'.

On 17 June 2019, Mohamed Morsi died of a heart attack while on trial for espionage. 'Former President Morsi's death followed years of government mistreatment, prolonged solitary confinement, inadequate medical care, and deprivation of family visits and access to lawyers,' tweeted Sarah Leah Whitson, Executive Director of Human Rights Watch's Middle East and North Africa division, adding that his death was 'terrible but entirely predictable'.

**

The Mubarak regime destroyed the very fabric of Egypt. It privatised the public sector, stole the state's money and squandered the returns from the Suez Canal. Provinces like Said and Sinai and many others were ignored. Neglected diplomatic relationships with the countries of the Nile led to misunderstandings and disputes over water. The education system was sabotaged, elections manipulated, and government institutions and ministries corrupted. Political prisoners were tortured or killed. Tens of thousands died, not just in terror attacks but also in the myriad of accidents on road and rail which a better government would have prevented. Mubarak's government allowed extremist Wahhabi Islam to invade Egypt. Drug use proliferated. It filled our culture with at best mediocre media and allowed our streets to become as polluted visually as they are with rubbish. Brilliant minds and diligent workers emigrated in vast numbers.

All this has returned. It is no wonder that my newsfeed in 2014 filled up with stories of young men and women committing suicide. Today, in 2020, young men and women who were active during the revolution are still committing suicide. The dream of undoing all the above has departed and pure souls are deciding to leave with it.

As soon as el-Sisi came to power, the army of journalists loyal to the new (old) regime started reciting the required narrative. The systems for supporting a dictator were still in place. Bassem Youssef's show was banned. A webpage called 'We approve of being watched by the Ministry of the Interior' shows a picture of a wall full of screens with Facebook accounts open and a man sitting monitoring. Activists recommended the German movie *The Lives of Others* to each other as a lesson in the surveillance mania of a police state. The el-Sisi regime bought millions of dollars worth of online surveillance tools from the US and other countries.

As time passes, more and more have gained the martyr status. In 2015, on the eve of the fourth anniversary of the 2011 uprising, a 28-year-old mother and activist from

Alexandria named Shaimaa al-Sabbagh went to Talaat Harb Square in downtown Cairo with a small group carrying signs and flowers to commemorate the revolution. She was shot in the back at close range and died choking on her own blood. By the end of the day, I have been told, 30 had been injured and 11 were dead. The number of people being killed on the streets in Egypt has continued to rise since 2011, with every anniversary of the revolution in particular witnessing a high rate of casualties within a few hours. Since 2015, few have dared to celebrate the revolution on 25 January.

**

In January 2011, like millions of other Egyptians, I stayed at home. But by November of the same year, nine months into the revolution, seeing a photo of people killed by the military and piled like rubbish in the street pushed me to start spraying messages in Tahrir Square. Between 2011 and 2013, I sprayed many campaigns on the streets of Cairo. It took me two years to understand and accept that I had become a street artist.

After el-Sisi was elected president in June 2014, a deep process of 'cleansing' most of the walls in Cairo took place. The city became graffiti free and sterile again. On 2 July 2014, a nineteen-year-old street artist, Hisham Rizk, was found dead in mysterious circumstances. The regime's message rang loud and clear: political artists are no longer welcome on the streets. The city does not belong to us anymore; we are strangers here again.

The last campaign I painted in Egypt was shortly before 30 June 2013. After that I stayed off the street. For a while I contemplated leaving the country, but then decided to stay. I kept teaching my courses and creating artworks with different international curators for museums and galleries abroad and avoided the local scene completely. In 2015, two years after my last work on the streets of Cairo, I was invited to exhibit in Freiburg in southern Germany. Germany is where I first exhibited my 'A Thousand Times No' installation, in Munich five years ago. I felt that this would be a good place for me to restart my street art practice. Freedom is addictive and I wanted to be on the street again. If the streets of Cairo were no longer accessible to me, then streets of other cities in the world would be.

To my surprise this small city near the borders with France and Switzerland had twelve legal walls for local street artists to paint on. An anti-Islamic wave was sweeping through Europe. Now my cause was no longer only about my locality but addressed to the world at large. The Nos, that had targeted specific evils in Egypt, became international Nos, refusing the things that blight lives everywhere: 'No to blood'; 'No to extremism'; 'No to discrimination'; 'No to borders'; 'No to killing'; 'No to fascism'; 'No to racism'; 'No to hatred'; 'No to violence'; 'No to war'; 'No to colonisation'; 'No to stupidity'; 'No to closed minds'.

The new series of Nos travelled with me to different cities around the world. Wherever I was invited to speak, I made sure to take stencils with me. I sprayed at night.

After Freiburg I went to Vancouver, New York, Madison, Istanbul, Tokyo, Stavanger, Chicago, San Antonio, London, Antwerp and Beirut. At first, I used the same general messages I had used in Freiburg. But as I connected more with different communities in the places I was visiting, I started to customise my Nos for each location. I sprayed 'No to Borders', 'No to Brexit', and 'No to Boris' in London, and 'No to the rule of the banks', 'No to corruption', and 'No to Stealing from the people' in Beirut. This No is very flexible and expressive. I do not think that I will stop spraying it anytime soon. But I don't know if I will ever be able to spray it again in Cairo in my lifetime.

Maybe you think that our revolution has failed and we have no solutions. It might look like that on the outside, and perhaps it is true that we have no solutions. But at least I have found the answers to the questions I was asking ten years ago. Why are there children begging on the street? Because we still do not collectively care about our weakest. Why can't I walk on a clean and even sidewalk? Because we do not consider the city to be our own and we do not feel that we are or are treated as citizens. Someone else is running the country and we do not have a say in anything. Why do I and other women have to think about what we are wearing ten times before we step out of our front doors for fear of harassment? Because oppressed societies only know how to oppress, and they usually oppress the weakest and the struggle for women's rights in the Arab world needs lawyers and legislators and judges and law enforcement, and before that happens we will keep hiding and feeling like prey walking down the street. Why can't we drink clean water from our taps even though we live in a country with one of the biggest rivers in the world? Because the infrastructure for providing clean water has been destroyed by a corrupt system of government and there are large companies profiting from our ignorance and possibly corrupt officials are getting a cut. Why are the beautiful Islamic monuments that I am studying in such terrible condition and some of them are being destroyed? Because losing memory and forgetting your identity and your past is part of the package of becoming an easy-to-control, obedient citizen. If you do not know, then you cannot object. How can I not feel guilty that my fridge is full when others are hungry? Because we are guilty and accomplice to the misery of others until we recognise it is in our hands to change things. Is it okay to be content with having access to resources and being safe yourself when others do not and are not? I will always be aware of my privileges. I will do what I can to help my fellow humans. Why am I still regarded as an outsider even though I gave birth to two Egyptian daughters and I speak Arabic with their accent? Because we live in a post-colonial world within borders we did not draw. We have all been brainwashed to believe that we can only exist in this or that piece of land. Anything beyond this narrative becomes unsettling. When you have been stripped of everything, nationalism and religion become the two crutches you hang on to. You need an illusion to survive the brutal reality. As to my eldest daughter's classic question: Why can't she become president of Egypt? My beautiful child, I promise you that we are laying the foundation so that one day you or your children will live to see a government worthy of your kindness, intelligence, culture and creativity. May you see days better than mine, and may your children live as producers and not consumers, as givers of science, knowledge and culture to this earth and not just receivers.

Previous page:
113. 'A Thousand Times No — Restaged' (series of 14 stencils), by Bahia Shehab, Antwerp, Belgium, November 2019

Next page:
114. 'A Thousand Times No — Restaged' (series of 14 stencils), by Bahia Shehab, New Orleans, US, October 2015

Last page:
115: 'A Thousand Times No — Restaged' (series of 14 stencils), by Bahia Shehab, Beirut, Lebanon, November 2019

When I reread what I wrote ten years ago, I feel naive. Sometimes I want to ask website admins to take down articles I wrote for their pages, but then I say to myself: I am not the same person now. She was a different human being and this is how she felt, and I should respect and accept that. I will not be ashamed of dreaming and believing in change, and what other people look at as failure I will look at as learning. I know now that we cannot change the world in a decade. I know that archaic systems take time to crumble. But I know too that ideas never die, and that we move on in life after such a monumental experience feeling more connected and hopefully having found some answers to the millions of questions we had and will keep having.

As I write these words, police brutality, imprisonment and assassination of activists, and the silencing of opposition have intensified. Will we go down to the streets again? We do not know. So far many people are still happy with their 'elected' president. The torture machine is still working. Part of society chooses to ignore the injustices being committed against people with views different to theirs, but how long can they really ignore what is happening? The road to justice is long and the biggest battles are yet to be fought. They might not be fought in large numbers on the streets anymore, but they will be fought. We planted the seeds. Whether we live to see them grow is a different question. Until the people fighting for peace become as organised as the people fighting for war, we will not get anywhere. Decades of corruption will not disappear overnight. What we are left with is the memory of a dream of a better Egypt that we tried without success to realise — **and the lessons we are still working to learn from our first ten years of revolution.**

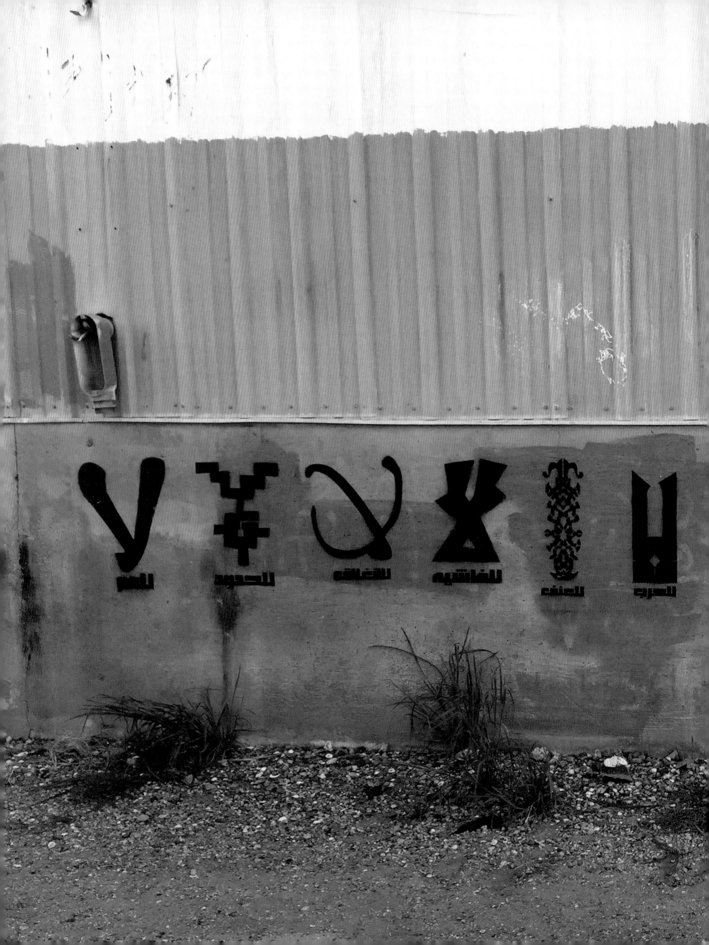

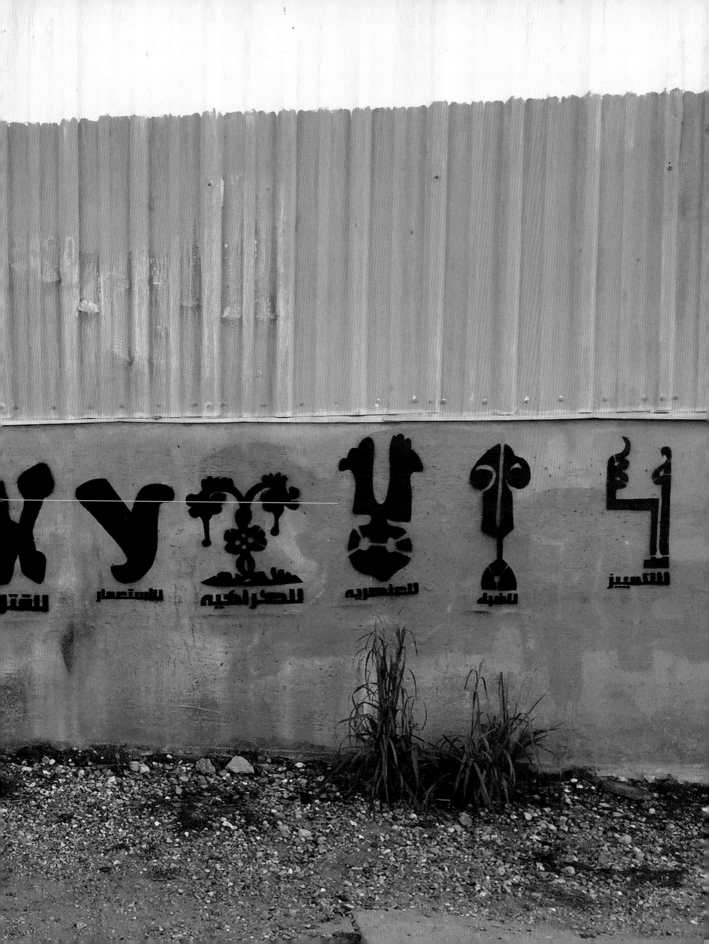

Bibliography

'6th of April Youth Movement,' Facebook page, www.facebook.com/photo.php?v=10150355578335678

'858: An archive of resistance,' https://858.ma/

'Activists Mourn Graffiti Artist Hisham Rizk,' Ahram Online, July 3, 2014, english.ahram.org.eg/NewsContent/1/64/105374/Index.aspx

Al-Masry Al-Youm, May 22, 2014, www.almasryalyoum.com/news/details/450529

Al-Masry Al-Youm, May 25, 2014, www.almasryalyoum.com/news/details/452080

'ANA MASRY INITIATIVE / for a better egypt,' Vimeo video, 1:00, posted by 'kalawi,' December 26, 2011, vimeo.com/34211952

'Angham Yanayer,' Youtube video, 1:38, posted by 'The Basement Records,' February 13, 2011, www.youtube.com/watch?v=q-_-NerfmgQ

'Arab Spring: A Research & Study Guide,' Cornell University Library, guides.library.cornell.edu/arab_spring

'August 2013 Rabaa Masacre,' Wikipedia, en.wikipedia.org/wiki/August_2013_Rabaa_massacre

Bains, Inderdeep, 'Day of shame in the Middle East: Female protesters beaten with metal poles as vicious soldiers drag girls through streets,' *Mail Online*, December 19, 2011, www.dailymail.co.uk/news/article-2075683/The-brave-women-Middle-East-Female-protesters-brutally-beaten-metal-poles-vicious-soldiers-drag-girls-streets-hair-day-shame.html

'Bassem Show,' Youtube video, 20:52, posted by 'Albernameg,' December 2, 2011, www.youtube.com/watch?feature=player_embedded&v=fzekOuIuDr8#!

'Cairokee ft Aida El Ayouby Ya El Medan,' Youtube video, 5:02, posted by 'CairokeeOfficial,' November 29, 2011, www.youtube.com/watch?feature=player_embedded&v=umlJJFVgYVI#at=67

Connolly, Kevin, 'Egypt vote: The weird and wonderful party logos', *BBC*, November 28, 2011, www.bbc.co.uk/news/magazine-15917630

'Egypt: Rab'a Killings Likely Crimes against Humanity,' Human Rights Watch, August 12, 2014, www.hrw.org/news/2014/08/12/egypt-rab-killings-likely-crimes-against-humanity

Eltahawy, Mona, 'Bruised but defiant: Mona Eltahawy on her assault by Egyptian security forces,' *The Guardian*, December 23, 2011, www.guardian.co.uk/world/2011/dec/23/mona-eltahawy-assault-egyptian-forces

Johnson, Dirk, 'Symbol of Pride, Inverted, Is Now Symbol of Political Dismay,' *The New York Times*, 17 December 17, 2012, www.nytimes.com/2012/12/18/us/politics/upside-down-flags-mark-conservative-anger-on-obama.html?_r=0

'Khaled Said compilation of one year of revolution images,' Facebook page, January 13, 2011, www.facebook.com/photo.php?fbid=157591384290734&set=a.157357257647480.28966.104224996294040&type=1&theater

'Live: The most powerful echo,' Youtube video, 5:11, posted by 'Noor Ayman,' February 3, 2012, www.youtube.com/watch?feature=player_embedded&v=w17GEETlVdg#!

Mackey, Robert, 'Protester Is Killed as Egyptian Police Attack Marchers Carrying Flowers to Tahrir Square,' *The New York Times*, January 24, 2015, www.nytimes.com/2015/01/25/world/middleeast/egypt-woman-is-killed-in-peaceful-cairo-protest.html?_r=3

'Madina – Ana Maygood,' Youtube video, 5:57, posted by 'Sema Abdelkader,' January 25, 2012, www.youtube.com/watch?v=uC_87iPyxHA

Magdy, Walid, 'Source in Ministry of Health: Rise in the Number of Demonstration Casualties to 11 Dead and 30 Injured,' *Al-Masry Al-Youm*, January 25, 2015, www.almasryalyoum.com/news/details/640853

'Mahed Eidy - Ahmed Fahmy,' Youtube video, 3:42, posted by 'Ahmed Neshaat,' February 17, 2011, www.youtube.com/watch?v=VTOkorGMT_E

'Mashrou' Leila - Ghadan Yawmon Afdal "Cover" (Official Music Video),' Youtube video, 4:07, posted by February 8, 2011, www.youtube.com/watch?v=OMadTojoJc8

'Medical student martyr,' Medantahreer, December 27, 2011, www.medantahreer.com/shownews-25692.php#.TvpJJnsobVg.facebook

'Morsi Meter!' Facebook page, www.facebook.com/MorsiMeter?fref=ts

'Nawara Nagm in al Azhar,' Youtube video, 1:29, posted by 'Emad Saleh,' December 17, 2011, www.youtube.com/watch?v=FvGrC78h7mU

'Psychology of the revolution,' Youtube video, 14:51, posted by 'Mohamed Nabil,' www.youtube.com/watch?v=CqzS9orhnSw&sns=fb

'Ramy Donjewan,' Youtube video, 2:53, posted by 'SiroMediaDesigns,' January 13, 2011, www.youtube.com/watch?v=Uwai6oTAcMM

'Revolution signs,' Revolution25january, egyptphotos.revolution25january.com/25january-photos.asp?c=4&id=24518

SCAF Crimes, December 19, 2011, scaf-crimes.blogspot.com

Scafcrimes, www.scafcrimes.net

'Scaf Crimes in Egypt,' Youtube video, 15:00, posted by 'Mahmoud Elmalt,' January 6, 2012, www.youtube.com/watch?v=jdmrFoq_kKs

'SCAF Remix,' Youtube video, 2:18, posted by 'Kharabeesh,' December 27, 2011, www.youtube.com/watch?feature=player_embedded&v=nP8OnAIW2nU

Scruton, Paul, Christine Oliver and Jack Shenker, 'Egyptian elections: the parties and where they stand – interactive,' *The Guardian*, November 22, 2011, www.guardian.co.uk/world/interactive/2011/nov/22/egypt-election-political-parties-interactive

Shah, Dhruti, 'Arab Spring: "It was the first time I felt I belonged",' *BBC*, December 26, 2011, www.bbc.co.uk/news/world-middle-east-16275176

Shehab, Bahia, 'A Thousand Times No!: Spray Painting as Resistance and the Visual History of the Lam-Alif,' *Contemporary Revolutions: Turning Back to the Future in 21st-Century Literature and Art*, ed. Susan Stanford Friedman, London 2018, 124-40.

Shehab, Bahia, 'A Thousand Times No,' *No Gods, No Masters, No Peripheries: Global Anarchisms*, eds. Barry Maxwell and Raymond Craib, Michigan 2015, 233–41.

Shehab, Bahia, 'Emotional Translation,' *Translating Dissent: Voices from and with the Egyptian Revolution*, ed. Mona Baker, New York 2016, 163–77.

Shehab, Bahia, 'Practicing Art in Revolutionary Times,' Nka 2020.46, 2020, 168–78.

Shehab, Bahia, 'Spraying NO,' *Walls of Freedom*, eds. Basma Hamdy and Don Karl, Malta 2014, 117–19.

'Sina'at al kazib,' Youtube video, 1:09:49, posted by 'ifilmsTV (member of iFG Media Group),' January 4, 2012, www.youtube.com/watch?v=BWZ9SLrvVUQ

Souief, Ahdaf, 'Image of Unknown Woman Beaten by Egypt's Military Echoes around the World,' *The Guardian*, December 18, 2011, www.theguardian.com/commentisfree/2011/dec/18/egypt-military-beating-female-protester-tahrir-square

'Sout Al Horeya – Amir Eid - Hany Adel - Hawary On Guitar & Sherif On Keyboards,' Youtube video, 4:02, posted by 'Amir Eid,' February 10, 2011, www.youtube.com/watch?v=Fgw_zfLLvh8&feature=fvwrel

'Statement of the Army's General Leadership and Egyptian Armed Forces on the Excommunication of President Mohammad Morsi,' Youtube video, 8:12, July 4, 2013, www.youtube.com/watch?v=dAssiYJI fl 4

Suzee in the City, 'An Afternoon with Sad Panda,' July 11, 2017, suzeeinthecity.wordpress.com/2011/07/11/an-afternoon-with-sad-panda/

Suzee in the City, 'War on Graffiti – SCAF Vandalists Versus Graffiti Artists', February 6, 2012, suzeeinthecity.wordpress.com/2012/02/06/war-on-graffiti-scaf-vandalists-versus-graffiti-artists/

'Tafi el Nour ya Bahia,' Youtube video, 3:20, posted by 'MADO,' www.youtube.com/watch?feature=player_embedded&v=7fGzWkubo1o

'Tahrir routes,' Youtube video, 3:15, posted by 'Nor Hamdi,' January 23, 2012, www.youtube.com/watch?feature=player_embedded&v=53lam_Inx94#!

'Tahrir Ultras – February 3, 2012', Flickr page, www.flickr.com/photos/mosaaberising/sets/72157629149940045/

'Testament of a child on the street,' Youtube video, 7:20, posted by 'Ahmed Nabil,' December 16, 2011, www.youtube.com/watch?feature=player_embedded&v=gocb7E8SW5Q#!

'The Maspeiro Massacre | 9/10/11,' Youtube video, 9:01, posted by 'The Mosireen Collective,' November 11, 2011, www.youtube.com/watch?feature=player_embedded&v=0ot-0NEwc3E

'The Noise of Cairo (old Teaser),' Vimeo video, 6:40, posted by 'scenes from,' September 2, 2011, vimeo.com/28520129

'We are all Khaled Said,' Facebook page, www.facebook.com/ElShaheeed?fref=ts

'wellsbox – Ana mish asif ya rayyes Mohamed Al Nahhas,' Youtube video, 2:24, posted by 'welloza,' April 10, 2011, www.youtube.com/watch?v=6L6tsqGurEs&feature=related

'Why are we going down on January 25?' Youtube video, 13:08, posted by 'Michael El-Torky,' January 5, 2012, www.youtube.com/watch?feature=player_embedded&v=DHr5hE1vUeo#!

'Women March,' Youtube video, 4:09, posted by 'Omar Kamel,' December 20, 2011, www.youtube.com/watch?feature=player_embedded&v=8iMphaogjdY#!

'Ya Masr Hanet,' Youtube video, 9:01, posted by 'BBC News,' February 23, 2011, www.youtube.com/watch?v=gZqtLDWA5ng

'Yasqot 7okm Al 3asskar - Ahmed Rock - Revolution Records,' Youtube video, 4:18, posted by 'Revolution Records,' November 16, 2011, www.

youtube.com/watch?feature=player_embedded&v=OfGz3DR7ChU

انا عايز الشعب يثور ضدي لومحترمتش الدستور والقانون
'I want people to revolt against me if I don't respect the constitution and the law,' Youtube video, 0:51, posted by 'gornalgy elsawra,' November 23, 2012, www.youtube.com/watch?v=DJVP5_Y1Jjg

المتهم برمي الأطفال من فوق السطوح في الإسكندرية يعترف بجريمته اعتراف خطير وصعب
'Man accused of throwing children from a rooftop in Alexandria confesses to his crime, a dangerous and difficult confession,' Youtube video, 1:22, posted by 'Moaten Masry,' July 3, 2013, www.youtube.com/watch?v=ioCIUGCof50

اجمد شاب فى الارتجال يوم فرحة الشعب المصرى بتنحى مبارك
'The best young man in improvisation, Egyptian people's happiness on the day that Mubarak stepped down,' Youtube video, 11:10, posted by 'AbdElRaheem Ezzat,' February 12, 2011, www.youtube.com/watch?v=kcK6z9LpM2s&feature=related

«الأبنودي» يهدي «ضحكة المساجين» لعلاء عبدالفتاح»
' 'al'abnudi" dedicates "Smile of prisoners" for "Ala'a Abd ELfattah,' Youtube video, 12:19, posted by 'AlMasry AlYoum,' December 9, 2011, www.youtube.com/watch?feature=player_embedded&v=A137GxCOurM#

ثائر وقف فى وجه العسكر ليلقن قاداتهم درس فى الوطنيه
' A Rebel stood in the face of the military to teach their leaders a lesson in patriotism,' Youtube video, 13:45, posted by 'Ahmed Elkawasmy,' February 3, 2012, www.youtube.com/watch?v=uwF76Ocibq4

التريقه والنفخه الكبرى لاعلان احمد شفيق الشعبي
'Mockery and big blow to the popular announcement of Ahmed Shafiq,' Youtube video, 2:00, posted by 'Hesham afifi,' May 16, 2012, www.youtube.com/watch?v=U1B3UglmfMk&sns=fb

أهتزار مطار القاهرة بهتافات وصل حرارة مصر
' Cairo airport shook with chants of the arrival of "Harara" to Egypt,' Youtube video, 3:04, December 25, 2011, www.youtube.com/watch?v=jhjhJLXyMTI&feature=related

فشل مسيرة بالعباسية لتأييد العسكر
'The failure of a march in Abbasiya to support the military,' Youtube video, 3:21, posted by 'Al Vafd TV,' December 20, 2011, www.youtube.com/watch?feature=player_embedded&v=BDHp4ogh4Co#!

اخر كلمة قبل ٢٥ يناير.... أسماء محفوظ
'The last word before January 25 ... Asma Mahfouz,' Youtube video, 3:22, posted by 'Asmaa Mahfouz,' January 24, 2011, www.youtube.com/watch?v=hKgN6AoUWCU

ماتنزلش الميدان - شريف إسماعيل
' Don't go to the square - Sherif Ismail,' Youtube video, 3:41, posted by 'Sherif Esmail,' July 7, 2011, www.youtube.com/watch?v=SWmP3_72hls&feature=player_embedded#at=95

دليل التنين في انتخاب حمدين
'Dragon's guide in the election of Hamdeen,' Youtube video, 3:46, posted by 'akroob2,' May 14, 2012, www.youtube.com/watch?v=6RdOp3Ab3nA&sns=fb

قله مندسه | wellsbox
' Tucked minority | wellsbox,' Youtube video, 3:49, posted by 'WellsBoxShow,' July 7, 2011, www.youtube.com/watch?v=gnTbKDcSPGQ&feature=player_embedded#at=153

الغايب ملوش نايب للفنان احمد عدوية - الانتخابات
'The absentee has no share, the artist Ahmed Adaweya - the elections,' Youtube video, 3:58, posted by 'videos,' October 16, 2011, www.youtube.com/watch?v=1ZC9MZ1NRQs

١٨+) يستشهدون و هم غارقون في دمائهم علي بلاط المستشفى)
'(+18) Martyring while they were soaked in blood on the hospital court,' Youtube video, 4:09, posted by 'Hoquq Akhbar,' December 21, 2011, www.youtube.com/watch?v=CymnBxXoN_I&feature=share&skipcontrinter=1

المتهم برمي الأطفال من فوق السطوح في الإسكندرية يعترف بجريمته اعتراف خطير وصعب
' The accused of throwing children from the rooftop in Alexandria confesses to his crime, a dangerous and difficult confession,' Youtube video, 4:10, posted by 'elmasdrtv,' July 8, 2013, www.youtube.com/watch?v=ioCIUGCof50

رسالة المصريين حول العالم إلى الشعب والمجلس العسكري ٢٠١٢
'The message of Egyptians around the world to the people and the Military Council, 2012,' Youtube video, 4:45, posted by 'EgVibes,' January 22, 2012, www.youtube.com/watch?feature=player_embedded&v=vB221NaNw1w#!

قصيدة هشام الجخ مشهد رأسي من ميدان التحرير
'Hisham Al-Jakh's poem "A vertical scene from Tahrir Square",' Youtube video, 4:45, posted by 'yallatubey,' February 9, 2011, www.youtube.

com/watch?v=Jcu0-MMpSI8&feature=related

تحت المجهر - الطريق الى ٢٥ يناير
'Under the microscope - the road to the January 25,' Youtube video, 49:41, posted by 'Al Jazeera Channel,' March 15, 2011, www.youtube.com/watch?v=738_EReBFCs

هؤلاء يؤيدون حمدين صباحى
'Those support Hamdeen Sabahi,' Youtube video, 5:04, posted by 'eladlgroup,' May 17, 2012, www.youtube.com/watch?feature=player_embedded&v=RlUONr1dyG4#!

عبدالرحمن الأبنودي ورسالة إلى المجلس العسكري
'Abdul Rahman Al-Abnoudi and a message to the Military Council,' Youtube video, 6:03, posted by 'Dodi Khaledovich,' November 28, 2011, www.youtube.com/watch?v=bnEQg3GF5G0

هتاف طلبة التربية العسكرية جامعة عين شمس
'Chants by students of military education, Ain Shams University,' Youtube video, 6:09, posted by 'Bravesoul223223,' February 2, 2012, www.youtube.com/watch?feature=player_embedded&v=IU8b4bvL1kE#

حرارة يصل القاهرة والمئات يستقبلونه
' Harara arrives Cairo and hundreds in his reception,' Youtube video, 6:15, posted by 'Al Vafd TV,' December 25, 2011, www.youtube.com/watch?v=Mg6KQk8JgKg&sns=fb

طفى النور يابهيه كل العسكر حرامية
' Bahia, turn lights off, all soldiers are thieves,' Youtube video, 8:55, posted by 'tmtm3010,' July 23, 2010, www.youtube.com/watch?v=Vq6xXYa6YWg&feature=related

عمرو موسى - البرنامج الرئاسي - إعادة بناء مصر
'Amr Moussa - Presidential Program - Rebuilding Egypt,' Youtube video, 9:40, posted by 'shababby7ibmasr,' May 20, 2012, www.youtube.com/watch?feature=player_embedded&v=TRgMssGJgJw#!

Endnotes

1. Khaled Said was a young man from Alexandria who suffered from severe police brutality and was killed in police custody. They accused him of owning drugs and tortured him till he died. The images of his violently mutilated face rallied many people online.

2. 'A Thousand Times NO,' The Khatt Foundation Center for Arabic Typography, last modified March 14, 2020, http://www.khtt.net/page/25951/en.

3. Beans sold on the street as a snack.

4. Bahia Shehab, 'A Thousand Times No!: Spray Painting as Resistance and the Visual History of the Lam-Alif,' *Contemporary Revolutions: Turning Back to the Future in 21st-Century Literature and Art*, ed. Susan Stanford Friedman, London 2018, 125.

5. Bahia Shehab, 'A Thousand Times No,' No Gods, *No Masters, No Peripheries: Global Anarchisms*, eds. Barry Maxwell and Raymond Craib, Michigan 2015, 237.

6. Shehab, 'A Thousand Times No,' 238.

7. 'Bombing' or 'hitting' here means painting a lot of graffiti rapidly, often on many walls in an area. This sometimes results in the graffiti looking rougher than pieces that take longer to spray.

8. In traditional Islamic thought, *'awra* is something which must be hidden away, not shown in public, usually a part of the body.

9. The man, Hamada Saber, was at first too scared to confess to the brutality he experienced and even said that the police were actually saving him from the protestors, when everyone had seen the security forces beating his naked body. Later he reappeared on television to admit that the police had beaten him and apologised to all Egyptians for not telling the truth earlier.

10. A video depicting the process of painting the wall, titled 'After Blood', was uploaded to Youtube on 19 June 2013. Available at: https://youtu.be/OOJ_PsoJY7l.

11. In Egyptian Arabic *mozza* can mean 'sexy chick' or 'foxy lady' — a sometimes disrespectful term for an attractive woman if cat-called, here repurposed as the pseudonym of a bold female street artist.

12. Some street artists paste pre-drawn or printed images directly onto walls, rather than painting directly onto the walls. This enables them to create large complex images without spending hours at the wall.

13. For background information, see the Human Rights report 'Egypt: Epidemic of Sexual Violence'. Available at: http://www.hrw.org/news/2013/07/03/egypt-epidemic-sexual-violence.

14. See: http://www.zdf.de/ZDFmediathek/beitrag/video/1933146/Die--Street-Art-von-Bahia-Shehab?bc=sen;sst:1209114;sst1:1209114#/beitrag/video/1933146/Die--Street-Art-von-Bahia-Shehab.

15. See: https://www.hrw.org/news/2014/08/12/egypt-rab-killings-likely-crimes-against-humanity.

16. CC here means President Abdel Fattah el-Sisi.

17. *Nawal* is a term used by the Muslim Brotherhood to mock the Egyptian army.

18. The word *shimal* or 'left' means 'gay' in Egyptian slang.